W9-BYK-958

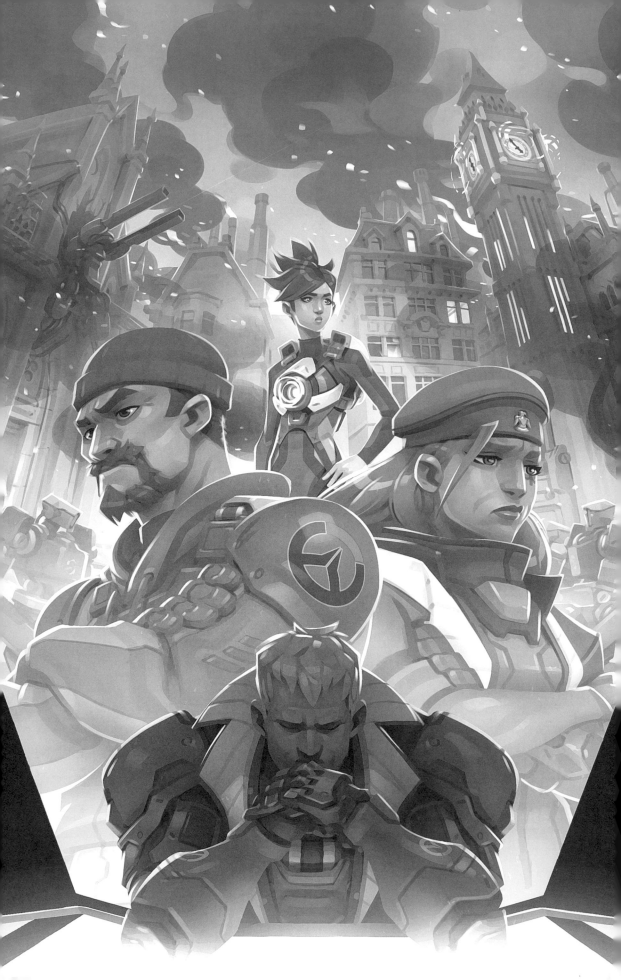

OVERWATCH®

ANTHOLOGY

VOLUME 1

SCRIPTS BY

Robert Brooks | Matt Burns | Michael Chu
Micky Neilson | Andrew Robinson | James Waugh

ART BY

Bengal | Jeffrey "Chamba" Cruz | Espen Grundetjern
Miki Montlló | Nesskain | Joe Ng | Gray Shuko

LETTERING BY

Richard Starkings and Comicraft's John Roshell,
Jimmy Betancourt, and Albert Deschesne

FRONT COVER ART

Miki Montlló

DARK HORSE BOOKS

BLIZZARD CREDITS

Writers: ROBERT BROOKS, MATT BURNS, MICHAEL CHU, MICKY NEILSON, ANDREW ROBINSON, JAMES WAUGH

Art Direction: LOGAN LUBERA

Editors: ROBERT SIMPSON, CATE GARY, ALLISON MONAHAN

Creative Consultation: CHRIS METZEN, JEFF KAPLAN, MICHAEL CHU, ARNOLD TSANG, BILL PETRAS, VALERIE WATROUS

Lore Consultation: SEAN COPELAND, JUSTIN PARKER, EVELYN FREDERICKSEN

Production: TIMOTHY LOUGHRAN, DEREK DUKE, ADAM GERSHOWITZ, CAROLINE HERNÁNDEZ, JOEL TAUBEL, RYAN THOMPSON

Project Manager: BRIANNE M LOFTIS

Senior Manager, Global Licensing: BYRON PARNELL

Director, Creative Development: RALPH SANCHEZ

Special Thanks: DOUG GREGORY, CHARLOTTE RACIOPPO, JEFFREY WONG, RACHEL DE JONG, MICHAEL BYBEE

DARK HORSE CREDITS

Publisher: MIKE RICHARDSON

Collection Editor: DAVE MARSHALL

Collection Assistant Editor: RACHEL ROBERTS

Collection Designers: DAVID NESTELLE and PATRICK SATTERFIELD

Digital Art Technician: ALLYSON HALLER

Facebook.com/DarkHorseComics

Twitter.com/DarkHorseComics

Advertising Sales: (503) 905-2537 | International Licensing: (503) 905-2377 | Comic Shop Locator Service: (888) 266-4226

OVERWATCH® ANTHOLOGY © 2017 Blizzard Entertainment, Inc. All rights reserved. Overwatch and Blizzard Entertainment are trademarks and/or registered trademarks of Blizzard Entertainment, Inc., in the U.S. and/or other countries. Dark Horse Books® is a trademark of Dark Horse Comics, Inc., registered in various categories and countries. All rights reserved. No portion of this publication may be reproduced or transmitted, in any form or by any means, without the express written permission of Dark Horse Comics, Inc. Names, characters, places, and incidents featured in this publication either are the product of the author's imagination or are used fictitiously. Any resemblance to actual persons (living or dead), events, institutions, or locales, without satiric intent, is coincidental.

This volume collects issues #1 through #12 of the digital comics series *Overwatch*, originally published by Blizzard Entertainment.

Published by
Dark Horse Books
A division of
Dark Horse Comics, Inc.
10956 SE Main Street
Milwaukie, OR 97222

DarkHorse.com
Blizzard.com
PlayOverwatch.com

First edition: October 2017
ISBN 978-1-50670-540-8

10 9 8 7 6 5 4 3 2 1
Printed in China

NEIL HANKERSON Executive Vice President ▲ TOM WEDDLE Chief Financial Officer ▲ RANDY STRADLEY Vice President of Publishing ▲ MATT PARKINSON Vice President of Marketing ▲ DAVID SCROGGY Vice President of Product Development ▲ DALE LaFOUNTAIN Vice President of Information Technology ▲ CARA NIECE Vice President of Production and Scheduling ▲ NICK McWHORTER Vice President of Media Licensing ▲ MARK BERNARDI Vice President of Book Trade and Digital Sales ▲ KEN LIZZI General Counsel ▲ DAVE MARSHALL Editor in Chief ▲ DAVEY ESTRADA Editorial Director ▲ SCOTT ALLIE Executive Senior Editor ▲ CHRIS WARNER Senior Books Editor ▲ CARY GRAZZINI Director of Specialty Projects ▲ LIA RIBACCHI Art Director ▲ VANESSA TODD Director of Print Purchasing ▲ MATT DRYER Director of Digital Art and Prepress ▲ SARAH ROBERTSON Director of Product Sales ▲ MICHAEL GOMBOS Director of International Publishing and Licensing

McCREE: *TRAIN HOPPER*

SCRIPT BY ROBERT BROOKS | ART BY BENGAL | LETTERING BY RICHARD STARKINGS AND Comicraft's JOHN ROSHELL AND JIMMY BETANCOURT

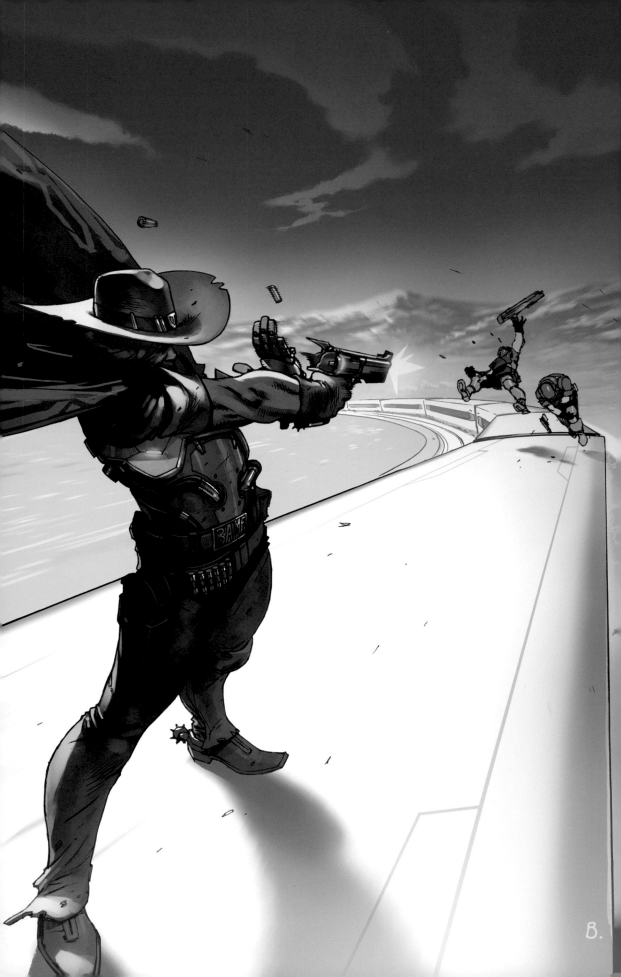

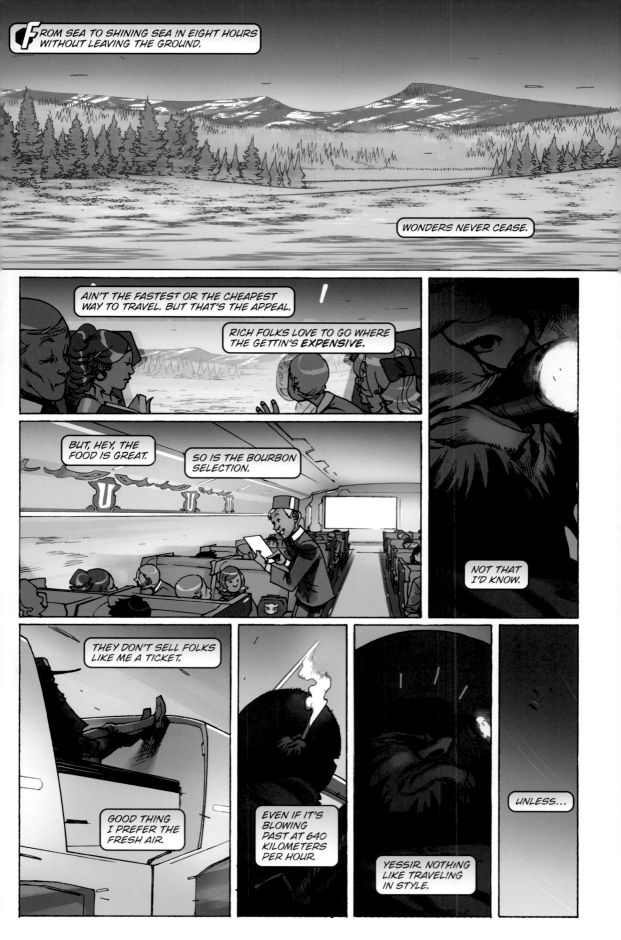

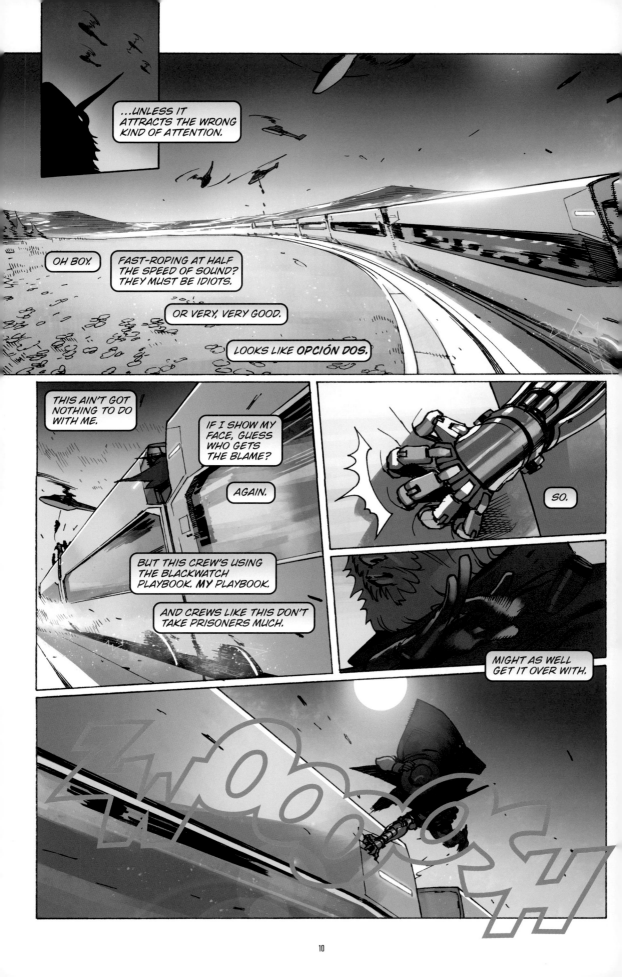

...UNLESS IT ATTRACTS THE WRONG KIND OF ATTENTION.

OH BOY.

FAST-ROPING AT HALF THE SPEED OF SOUND? THEY MUST BE IDIOTS.

OR VERY, VERY GOOD.

LOOKS LIKE OPCIÓN DOS.

THIS AIN'T GOT NOTHING TO DO WITH ME.

IF I SHOW MY FACE, GUESS WHO GETS THE BLAME?

AGAIN.

BUT THIS CREW'S USING THE BLACKWATCH PLAYBOOK. MY PLAYBOOK.

AND CREWS LIKE THIS DON'T TAKE PRISONERS MUCH.

SO.

MIGHT AS WELL GET IT OVER WITH.

ZWOOOSH

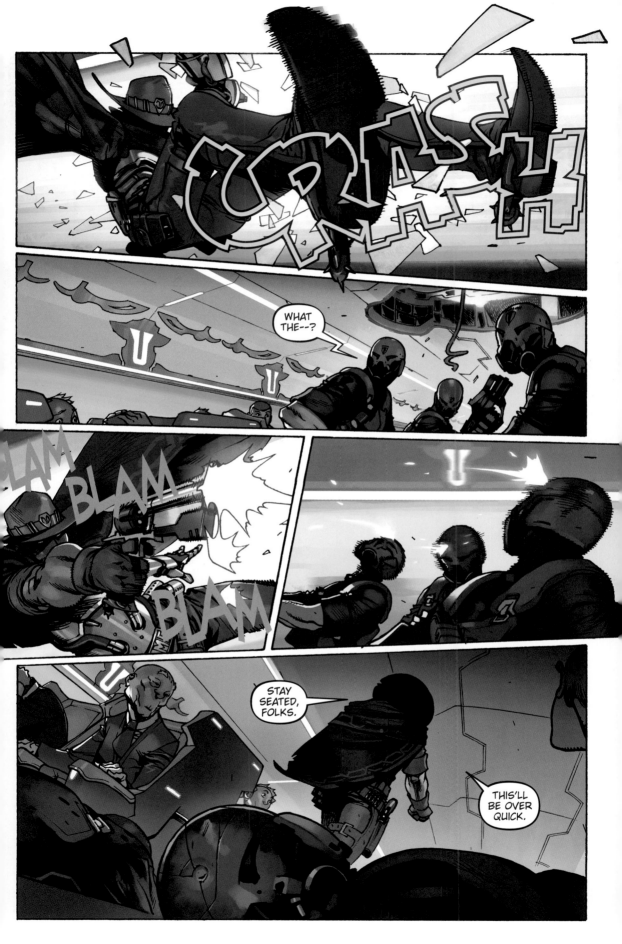

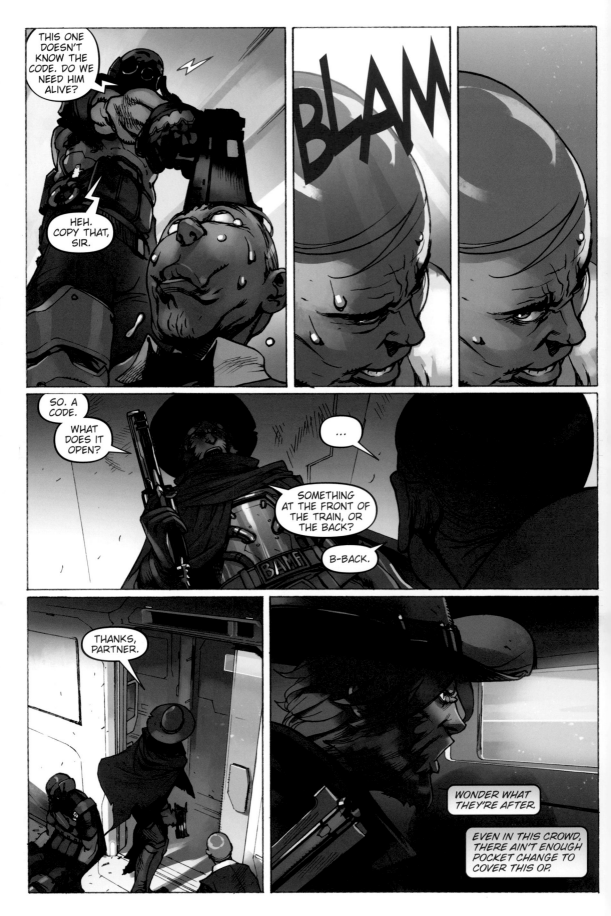

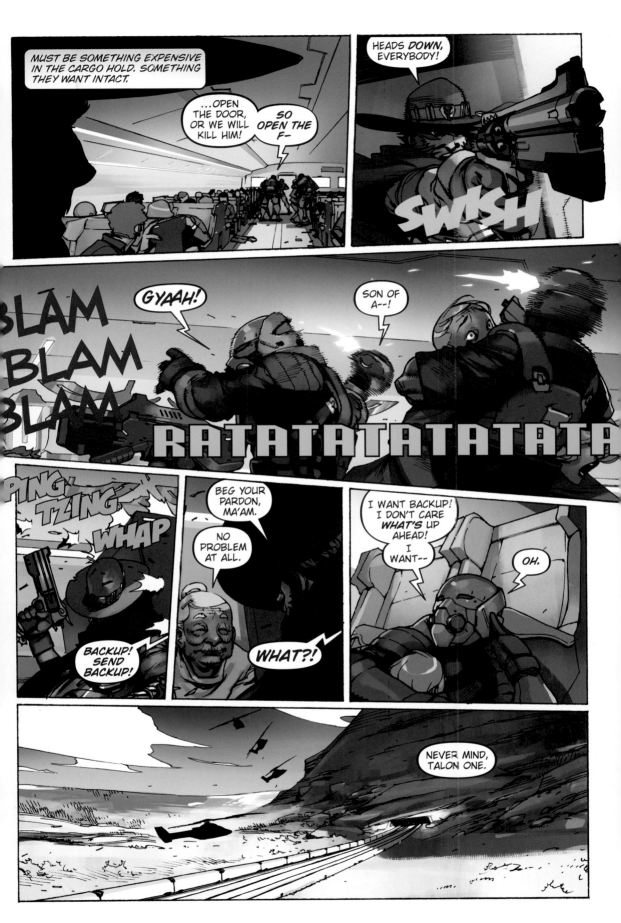

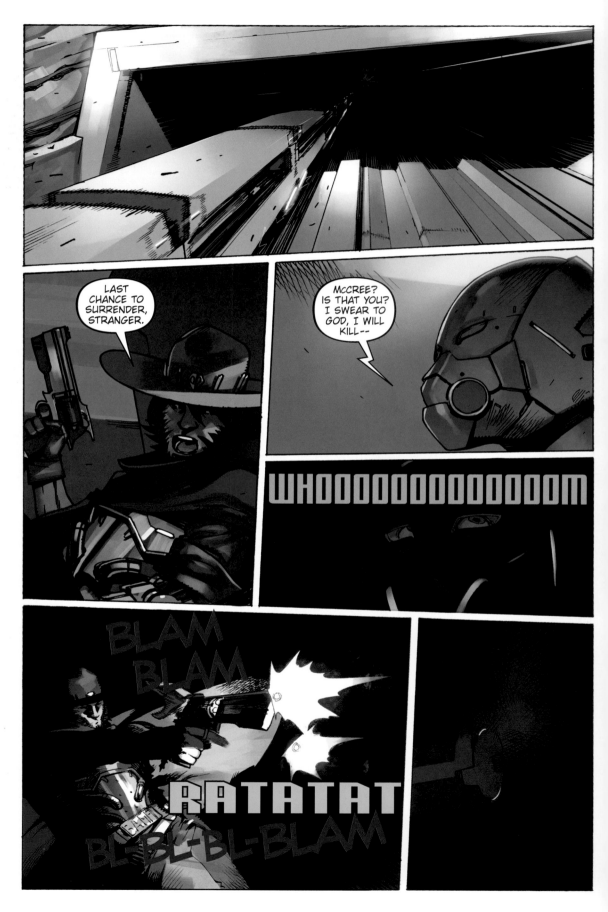

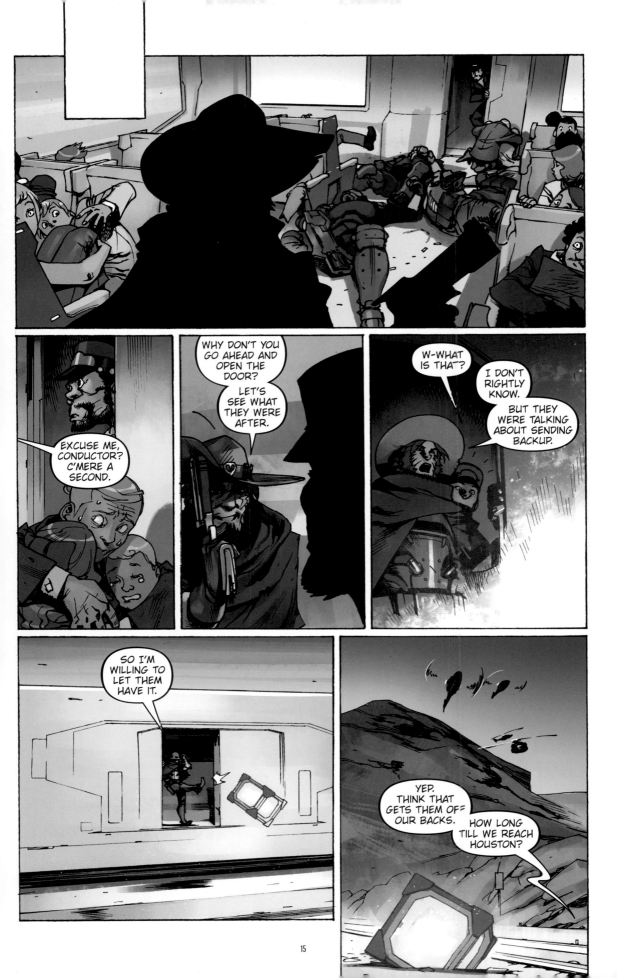

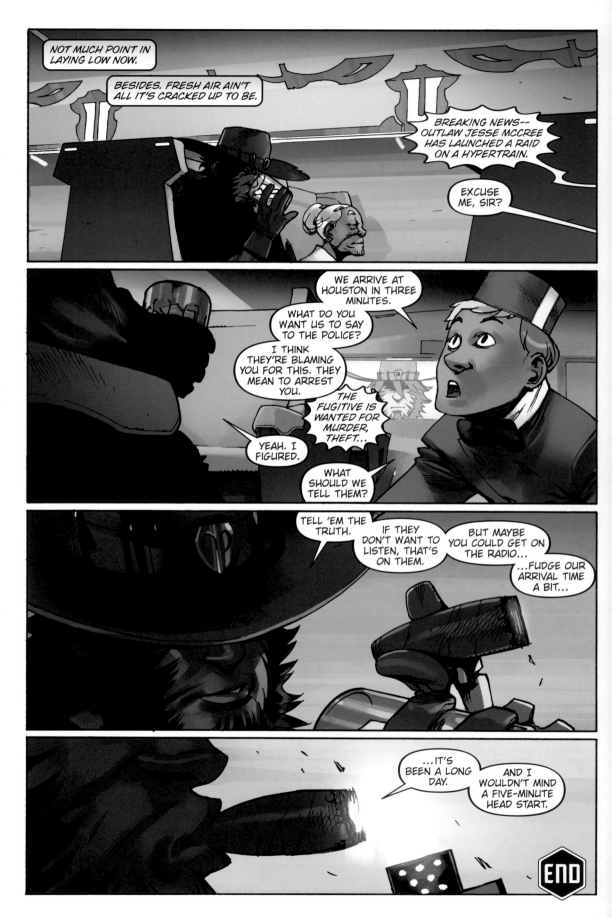

REINHARDT: DRAGON SLAYER

SCRIPT BY MATT BURNS | ART BY NESSKAIN | LETTERING BY RICHARD STARKINGS AND Comicraft's JOHN ROSHELL AND JIMMY BETANCOURT

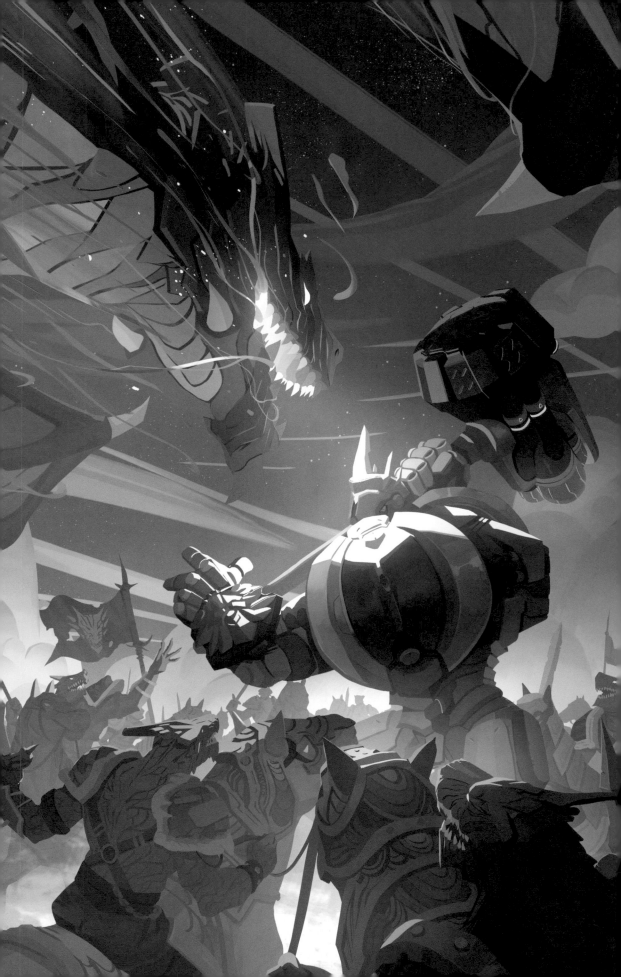

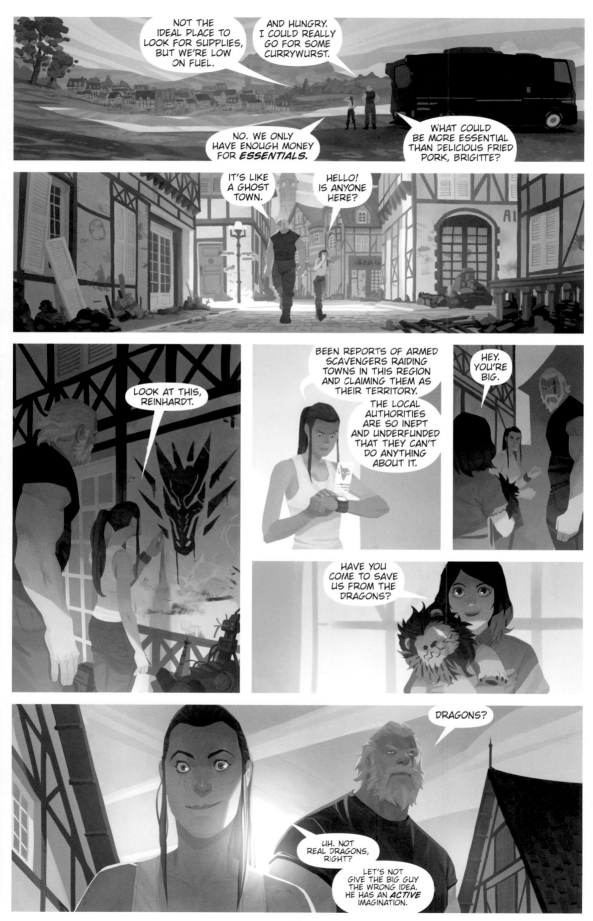

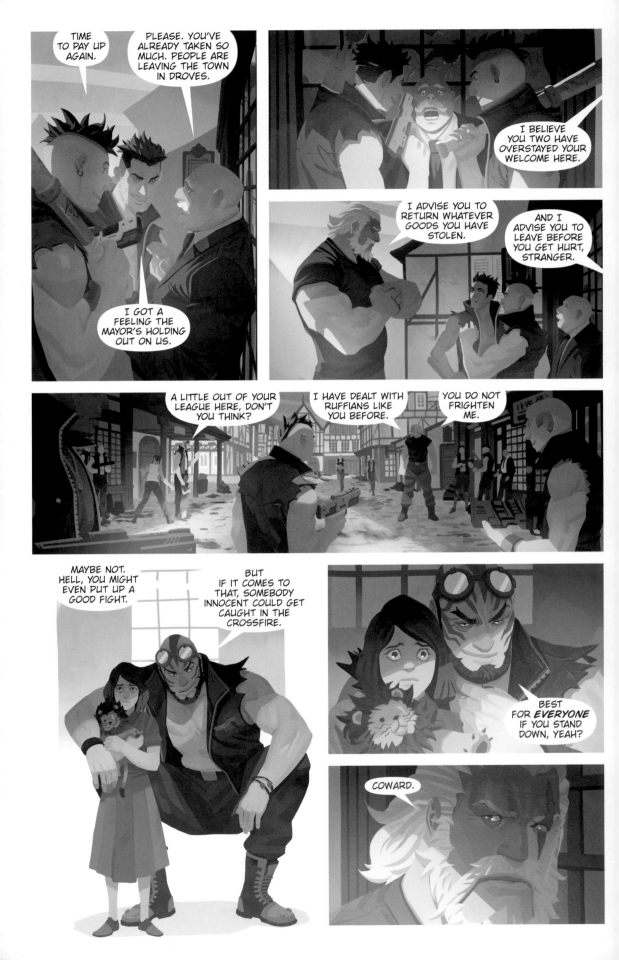

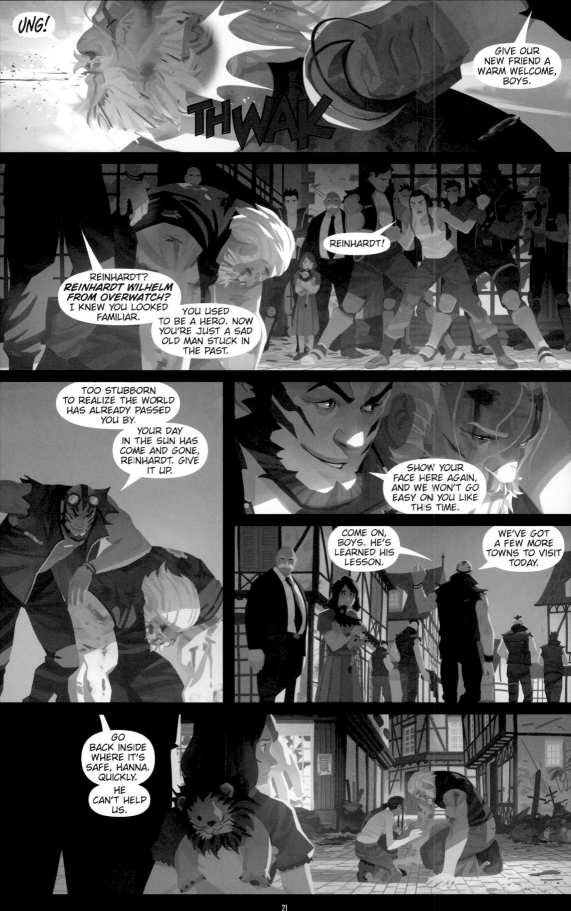

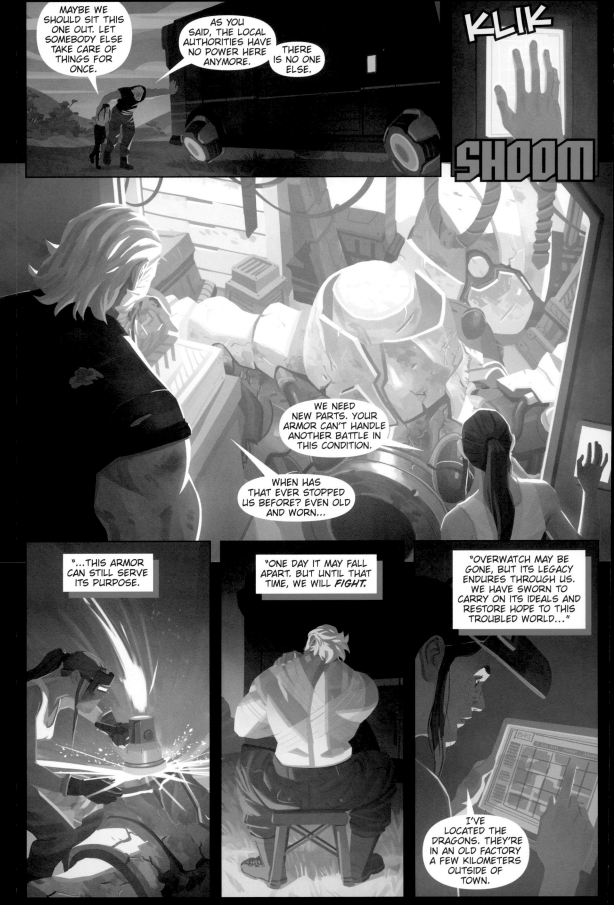

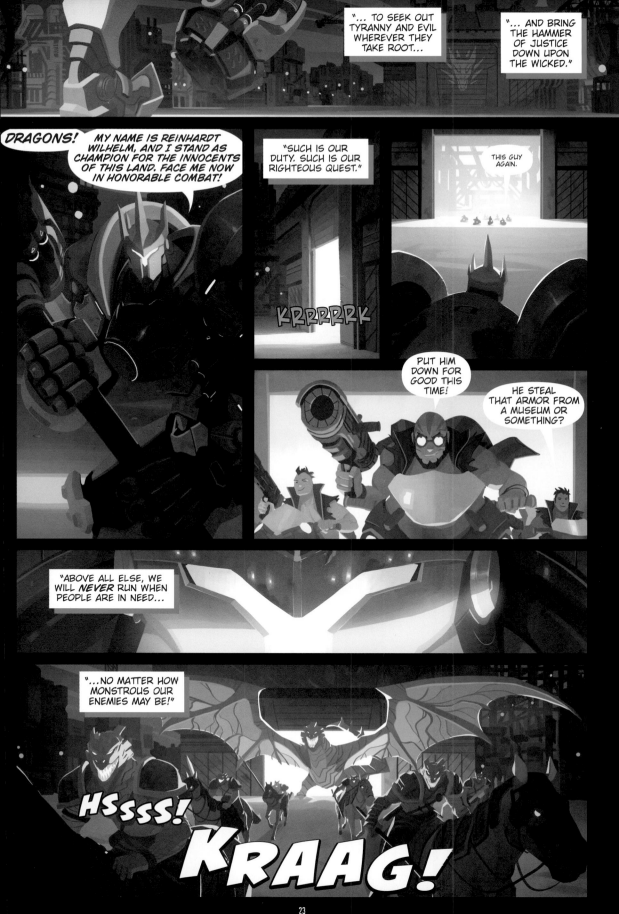

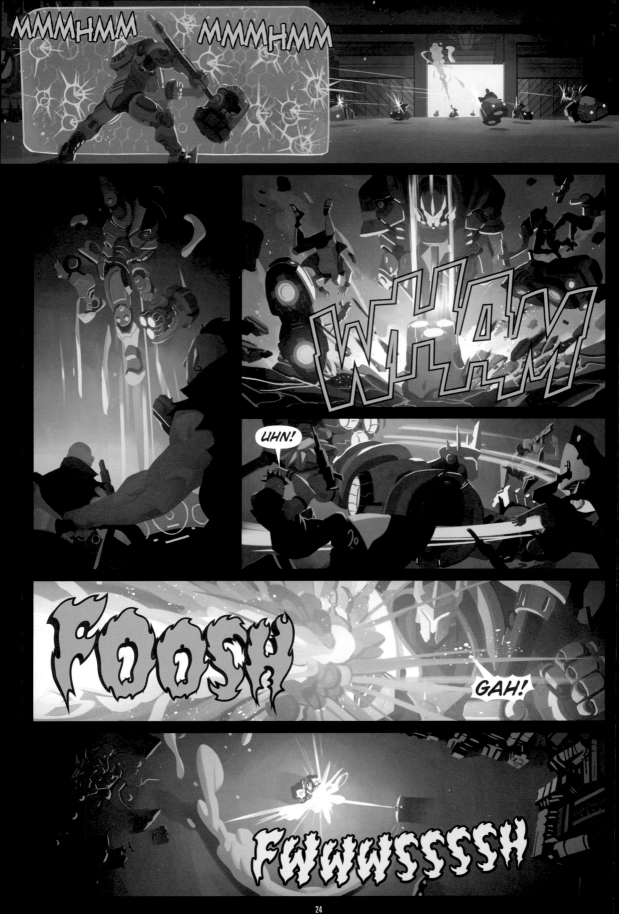

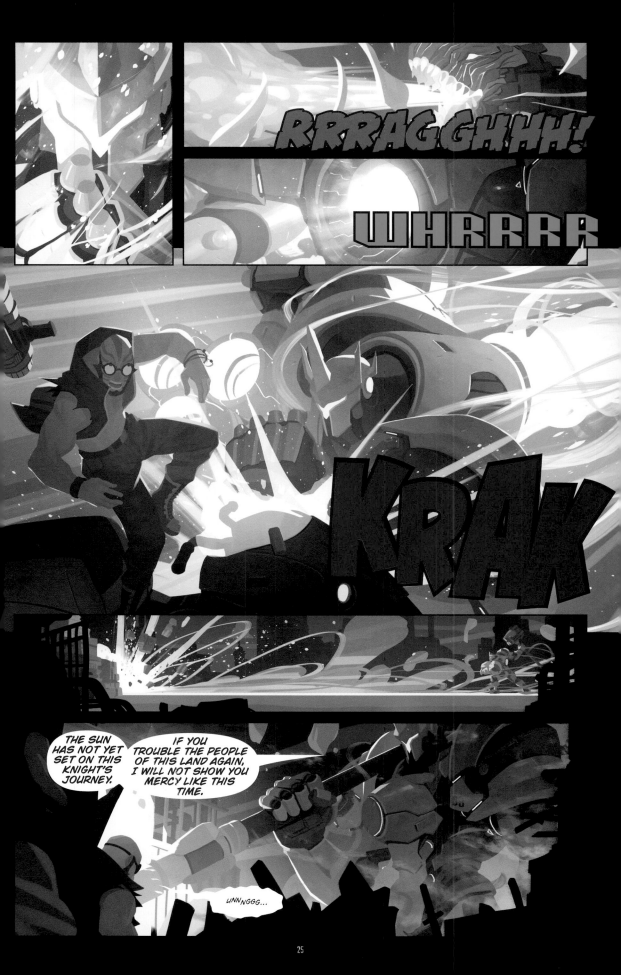

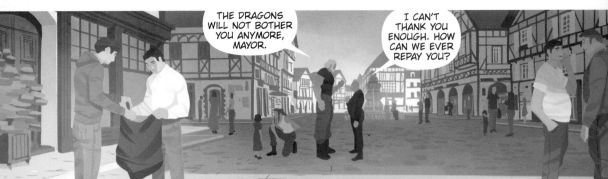

THE DRAGONS WILL NOT BOTHER YOU ANYMORE, MAYOR.

I CAN'T THANK YOU ENOUGH. HOW CAN WE EVER REPAY YOU?

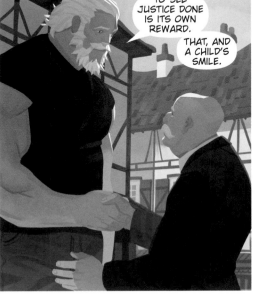

TO SEE JUSTICE DONE IS ITS OWN REWARD.

THAT, AND A CHILD'S SMILE.

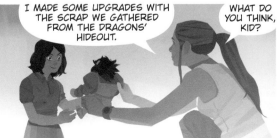

I MADE SOME UPGRADES WITH THE SCRAP WE GATHERED FROM THE DRAGONS' HIDEOUT.

WHAT DO YOU THINK, KID?

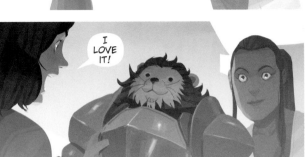

I LOVE IT!

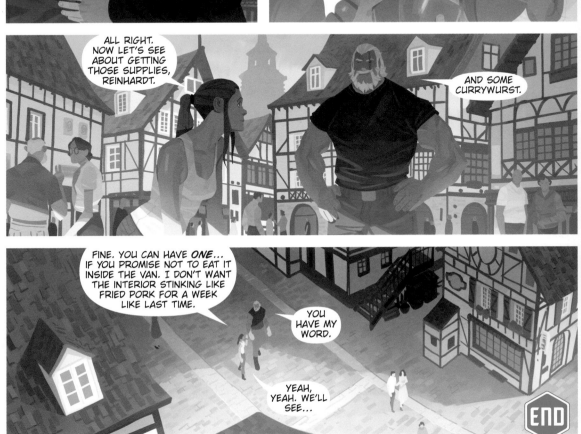

ALL RIGHT. NOW LET'S SEE ABOUT GETTING THOSE SUPPLIES, REINHARDT.

AND SOME CURRYWURST.

FINE. YOU CAN HAVE **ONE**... IF YOU PROMISE NOT TO EAT IT INSIDE THE VAN. I DON'T WANT THE INTERIOR STINKING LIKE FRIED PORK FOR A WEEK LIKE LAST TIME.

YOU HAVE MY WORD.

YEAH, YEAH. WE'LL SEE...

END

JUNKRAT & ROADHOG: *GOING LEGIT*

SCRIPT BY ROBERT BROOKS | ART BY GRAY SHUKO | LETTERING BY RICHARD STARKINGS
AND Comicraft's JOHN ROSHELL AND JIMMY BETANCOURT

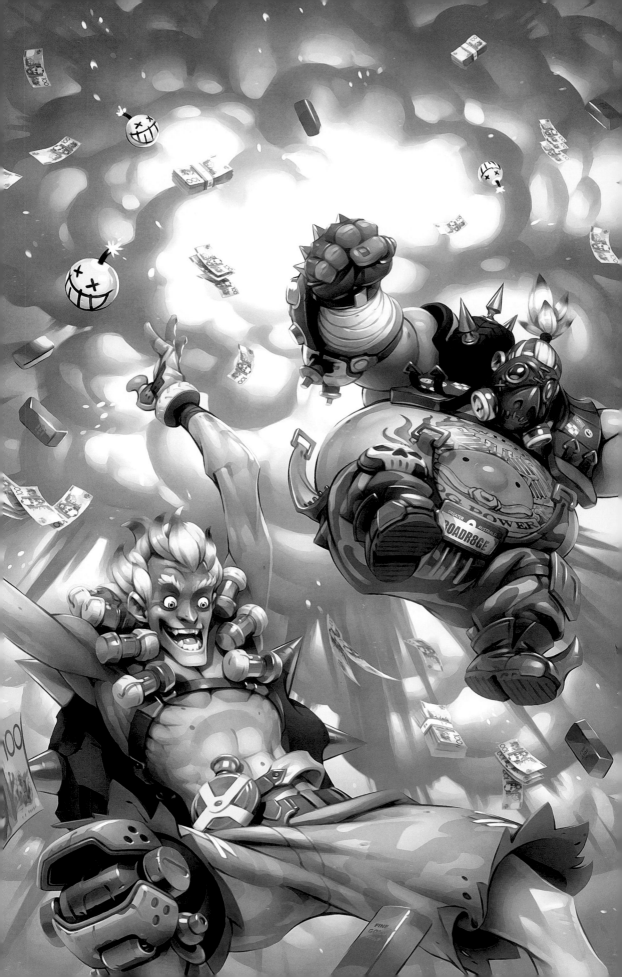

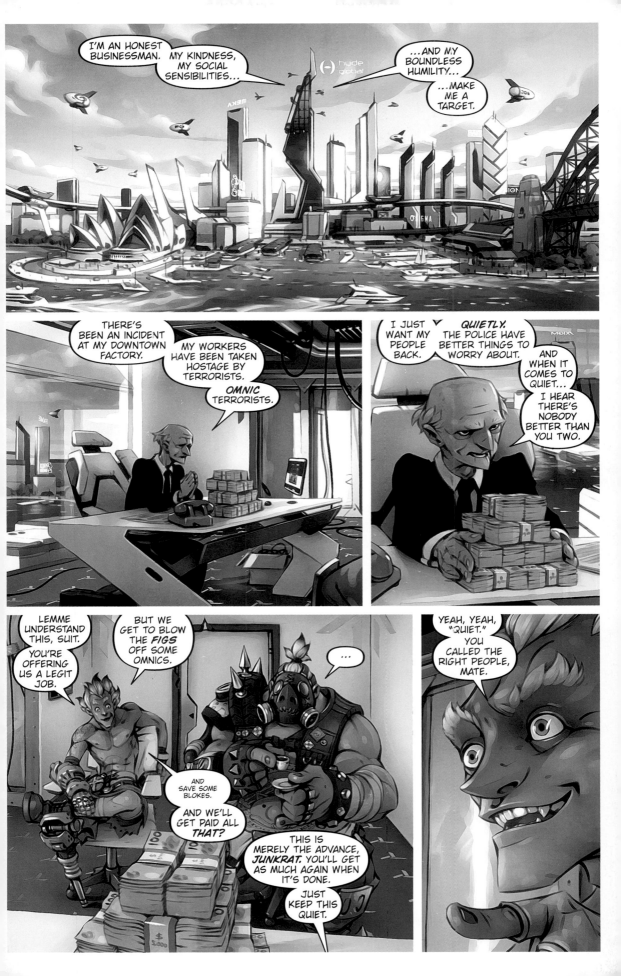

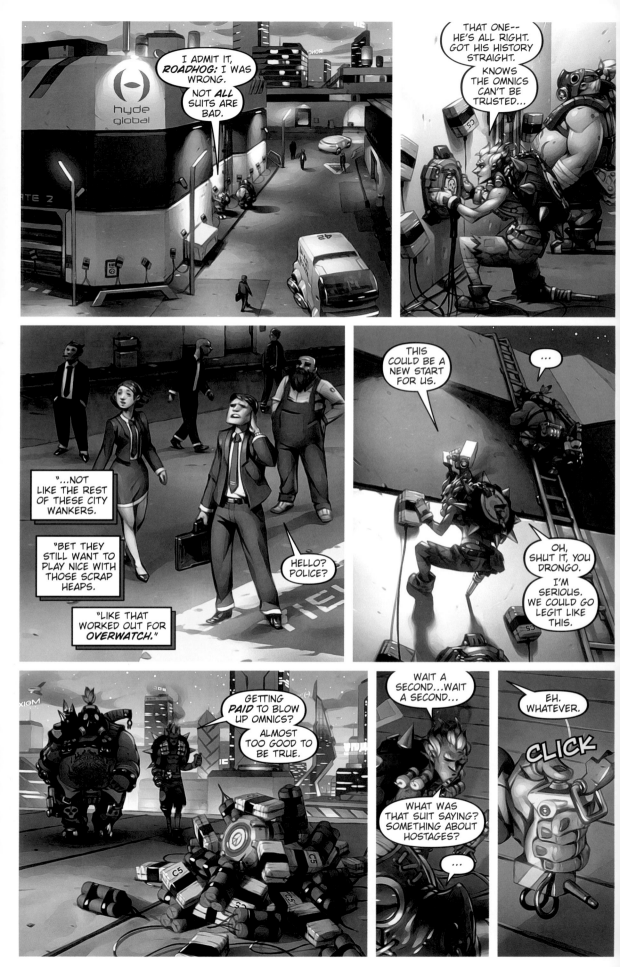

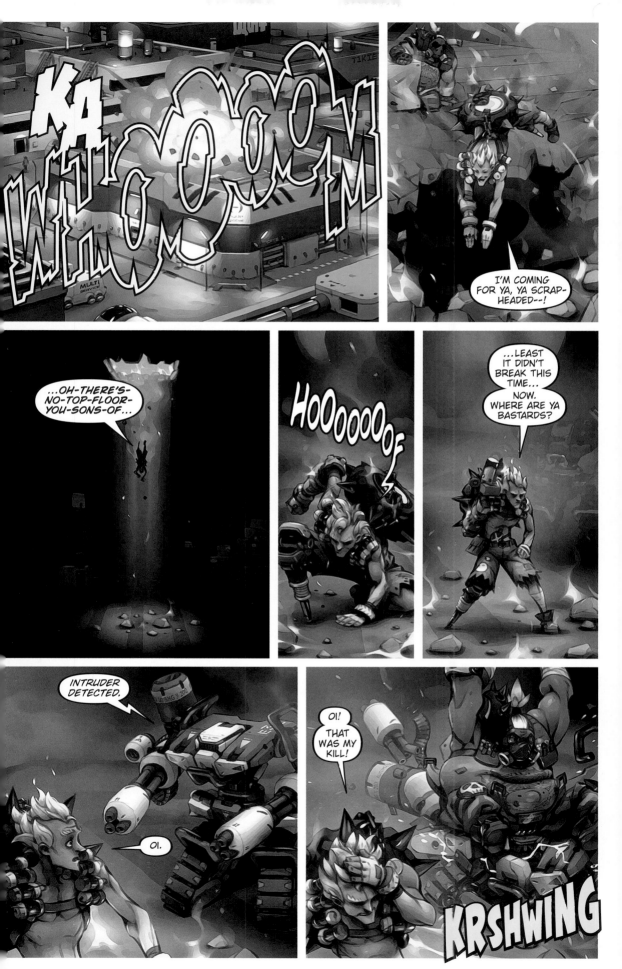

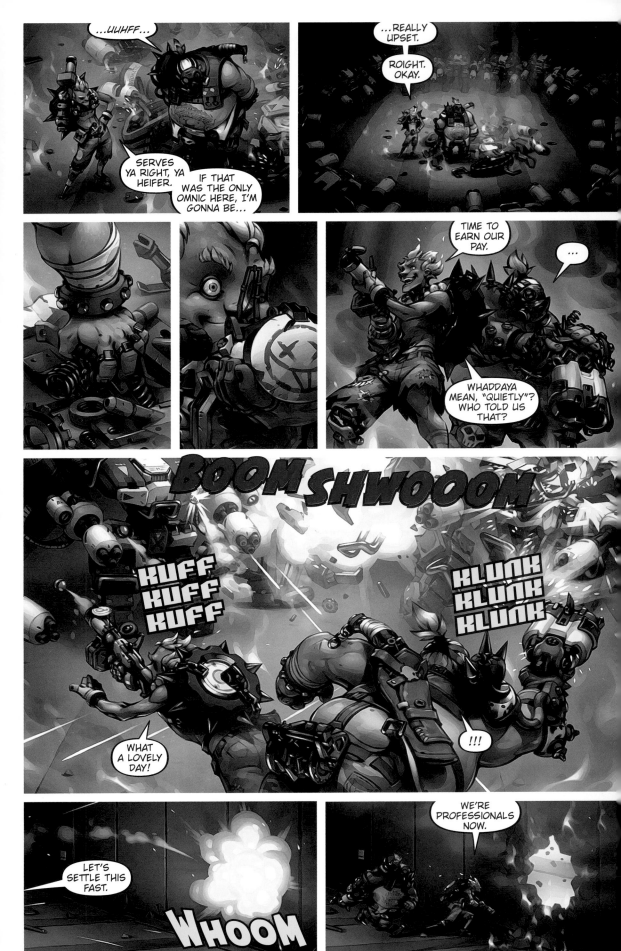

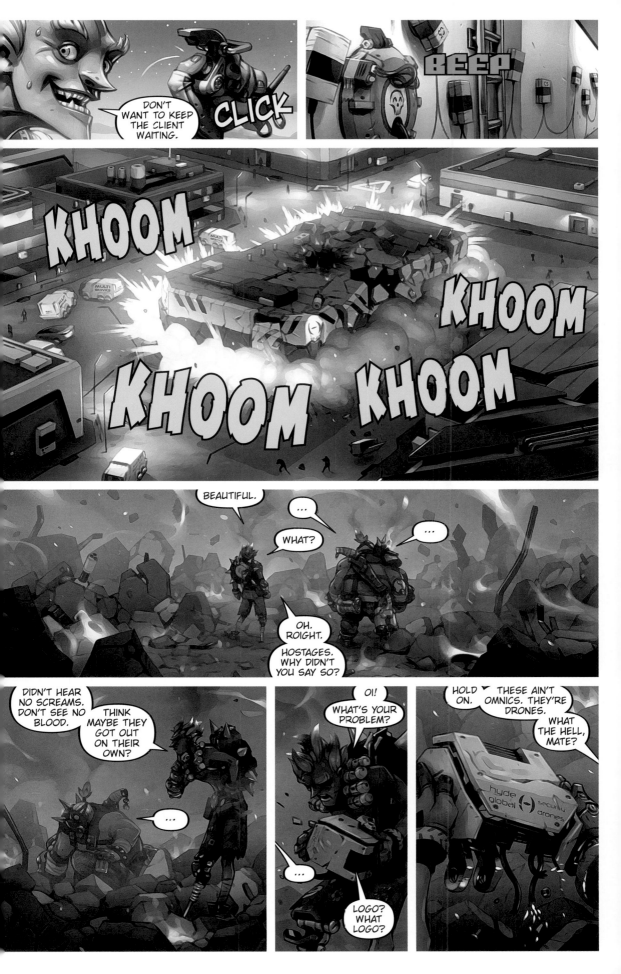

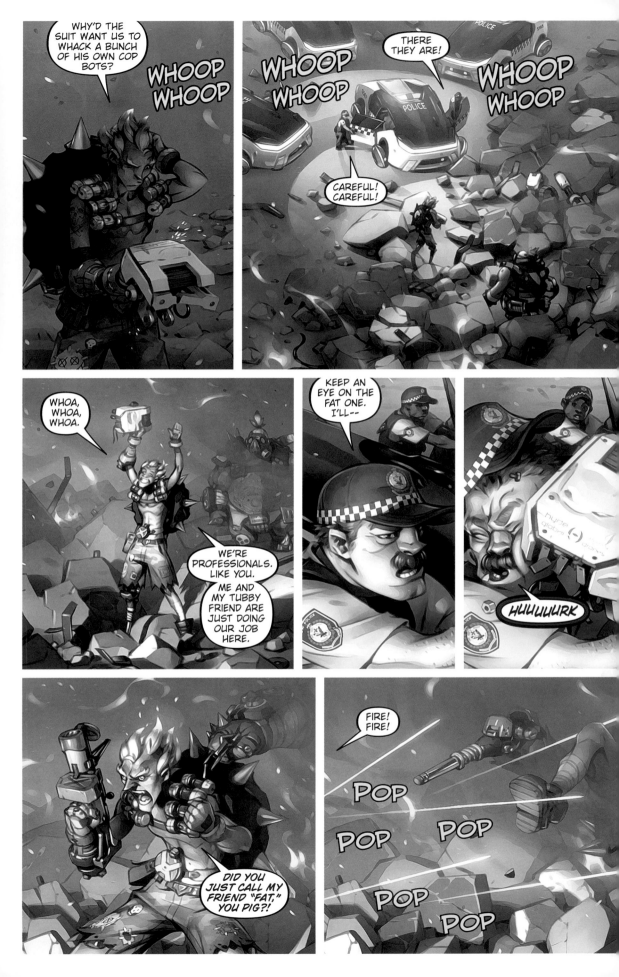

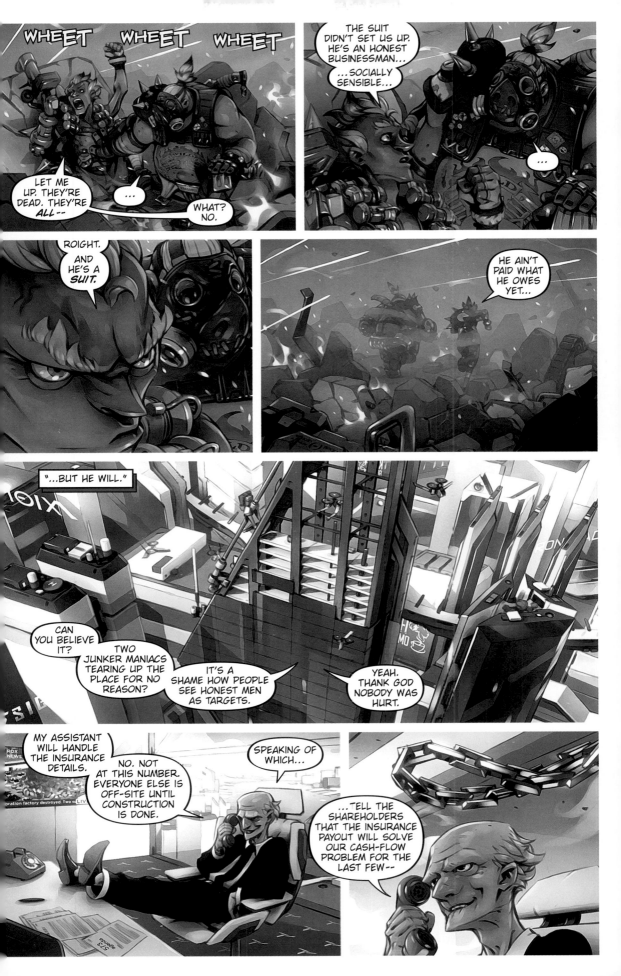

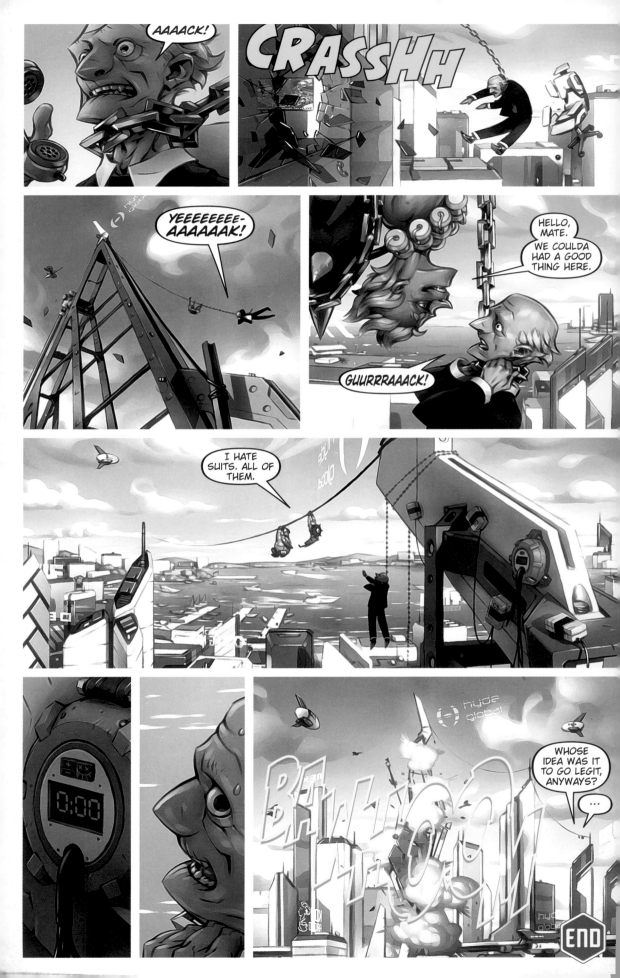

SYMMETRA: *A BETTER WORLD*

SCRIPT BY ANDREW ROBINSON | ART BY JEFFREY "CHAMBA" CRUZ

LETTERING BY RICHARD STARKINGS

AND Comicraft's JOHN ROSHELL AND JIMMY BETANCOURT

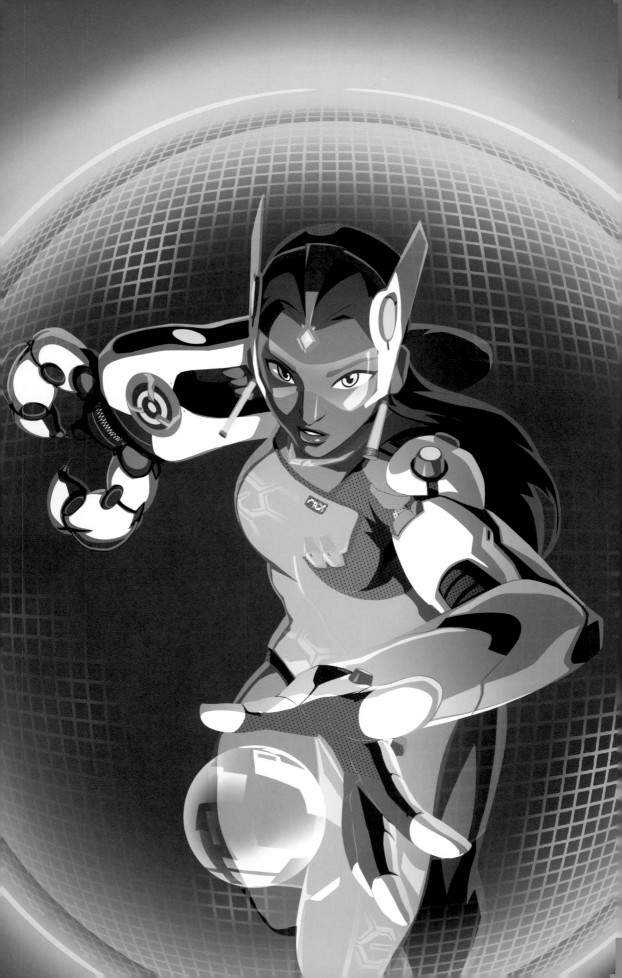

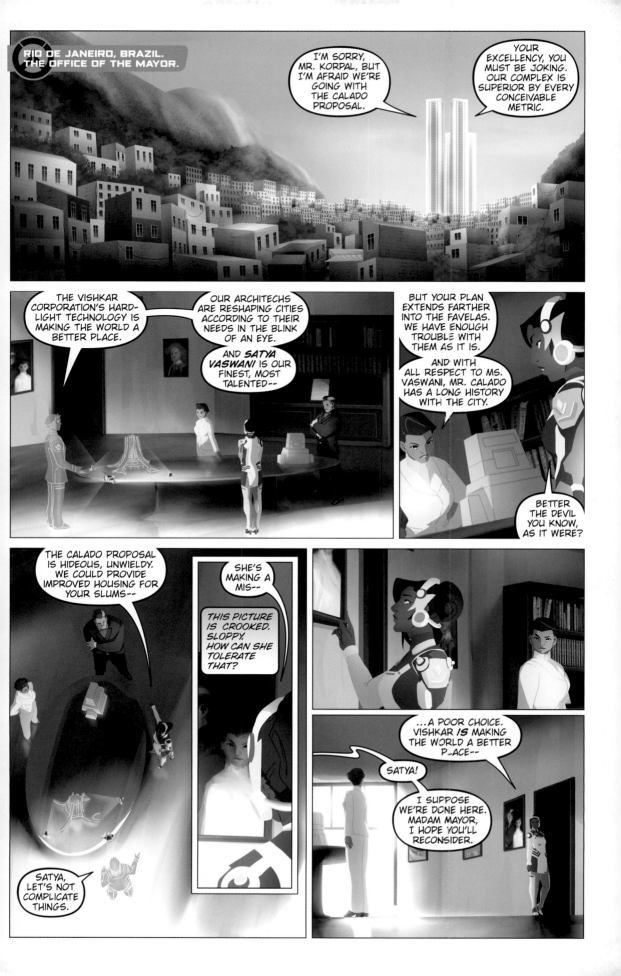

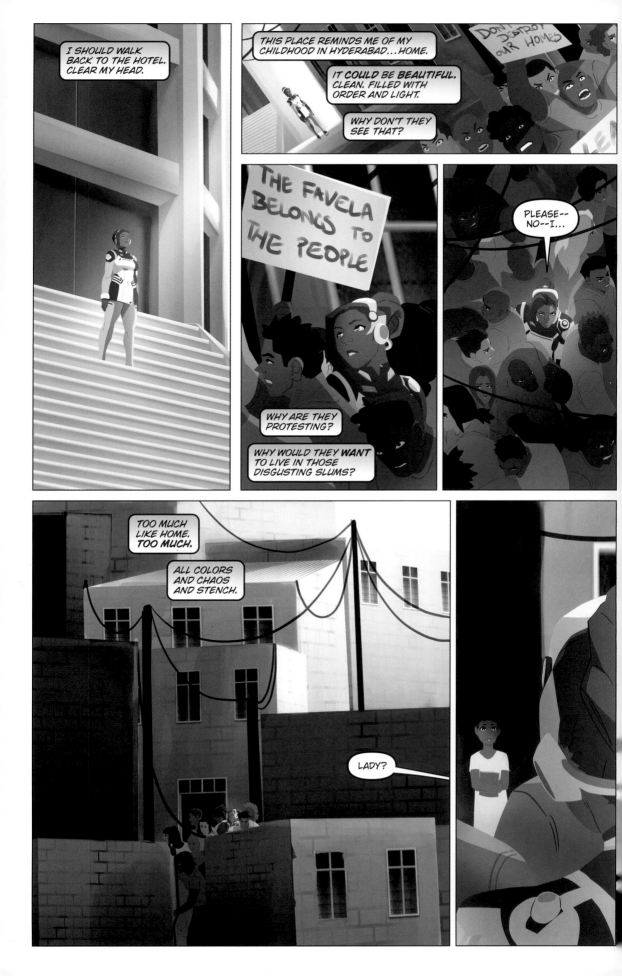

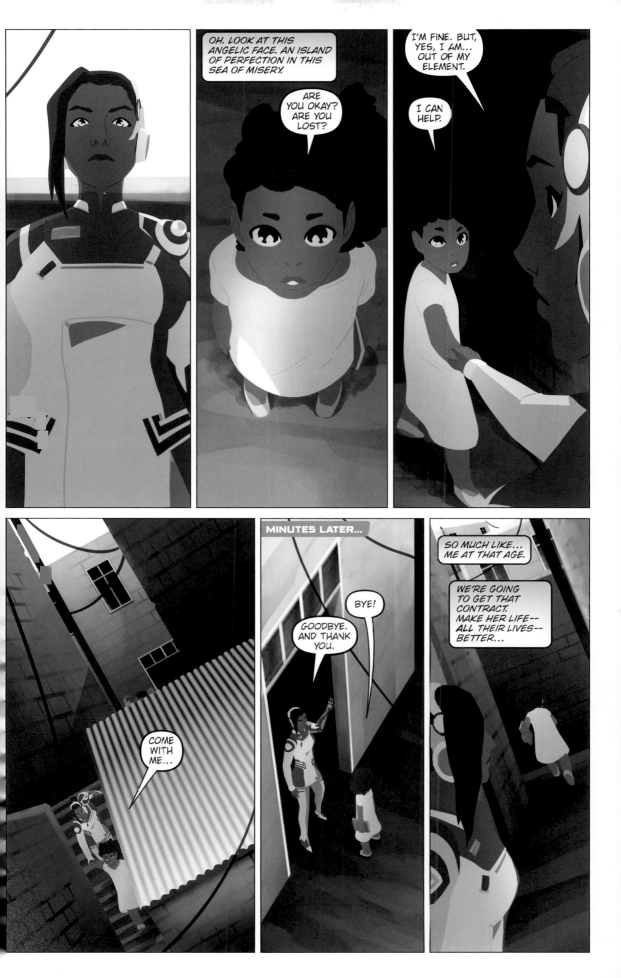

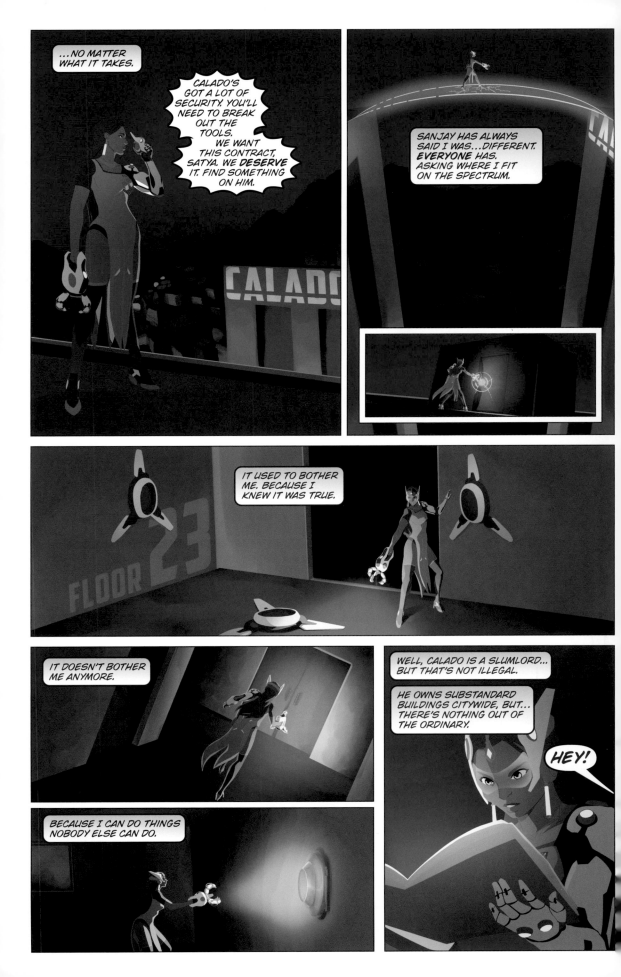

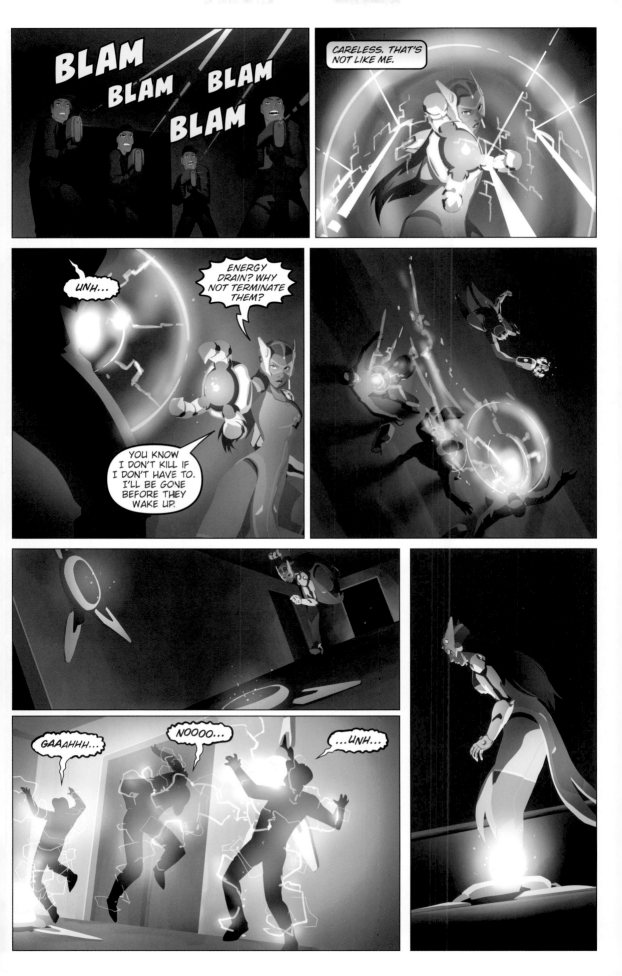

SANJAY? I'M AFRAID THERE'S NOT ENOUGH ON CALADO.

PERHAPS WE CAN GET TO THE MAYOR INSTEAD, FIND SOMETHING ON HER.

THAT IS DISAPPOINTING. BUT SO BE IT.

BAMF

CALADO

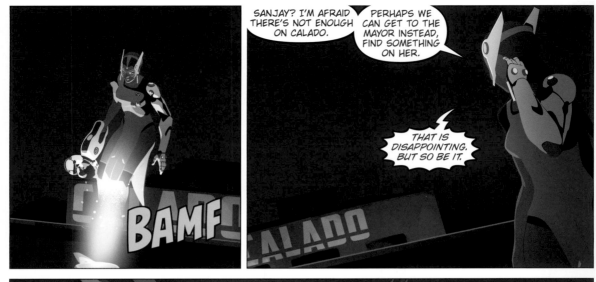

KA THOOM

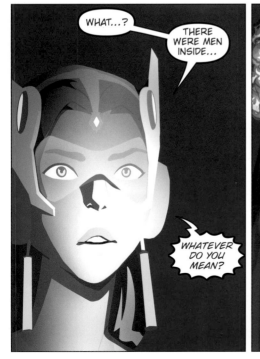

WHAT...?

THERE WERE MEN INSIDE...

WHATEVER DO YOU MEAN?

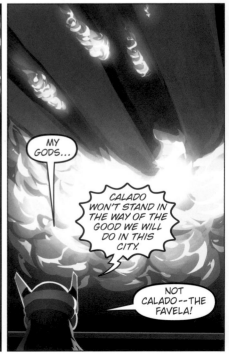

MY GODS...

CALADO WON'T STAND IN THE WAY OF THE GOOD WE WILL DO IN THIS CITY.

NOT CALADO--THE FAVELA!

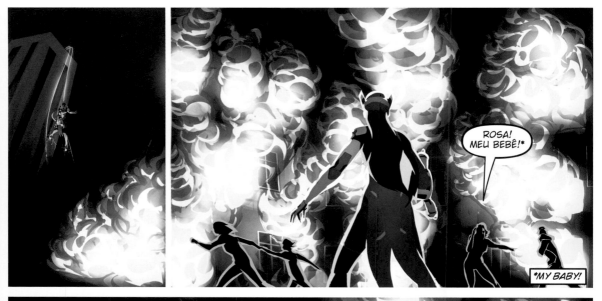

ROSA! MEU BEBÊ!*

*MY BABY!

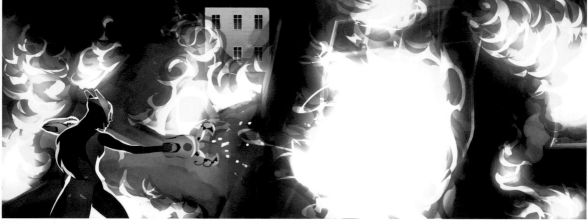

THERE...

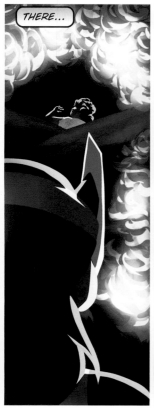

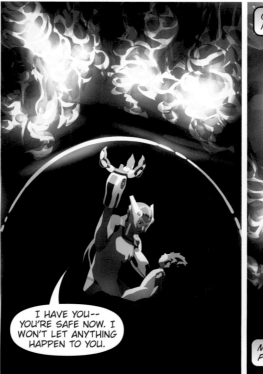

I HAVE YOU—YOU'RE SAFE NOW. I WON'T LET ANYTHING HAPPEN TO YOU.

OH. NO. HER FACE. IT'S...RUINED.

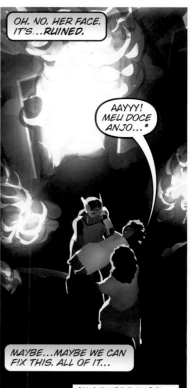

AAYYY! MEU DOCE ANJO...*

MAYBE...MAYBE WE CAN FIX THIS. ALL OF IT...

*MY SWEET ANGEL...

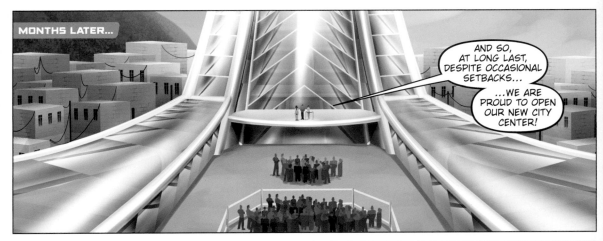

AND SO, AT LONG LAST, DESPITE OCCASIONAL SETBACKS...

...WE ARE PROUD TO OPEN OUR NEW CITY CENTER!

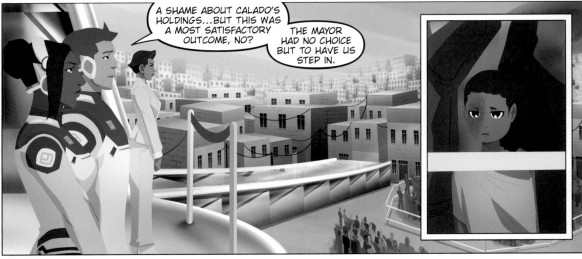

A SHAME ABOUT CALADO'S HOLDINGS...BUT THIS WAS A MOST SATISFACTORY OUTCOME, NO?

THE MAYOR HAD NO CHOICE BUT TO HAVE US STEP IN.

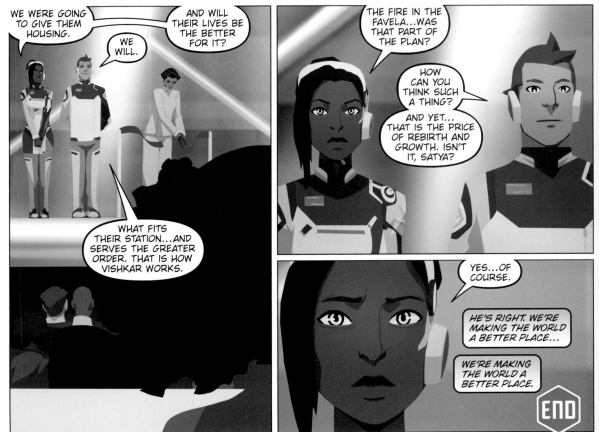

WE WERE GOING TO GIVE THEM HOUSING.

AND WILL THEIR LIVES BE THE BETTER FOR IT?

WE WILL.

WHAT FITS THEIR STATION...AND SERVES THE GREATER ORDER. THAT IS HOW VISHKAR WORKS.

THE FIRE IN THE FAVELA...WAS THAT PART OF THE PLAN?

HOW CAN YOU THINK SUCH A THING?

AND YET... THAT IS THE PRICE OF REBIRTH AND GROWTH. ISN'T IT, SATYA?

YES...OF COURSE.

HE'S RIGHT. WE'RE MAKING THE WORLD A BETTER PLACE...

WE'RE MAKING THE WORLD A BETTER PLACE.

END

PHARAH: MISSION STATEMENT

SCRIPT BY ANDREW ROBINSON | ART BY NESSKAIN | LETTERING BY RICHARD STARKINGS
AND Comicraft's JOHN ROSHELL AND JIMMY BETANCOURT

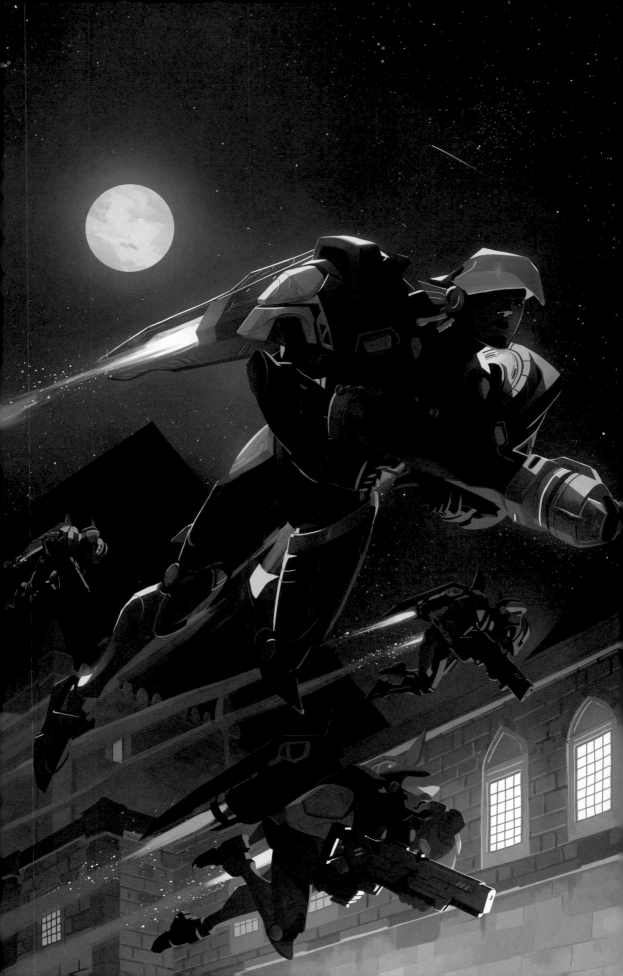

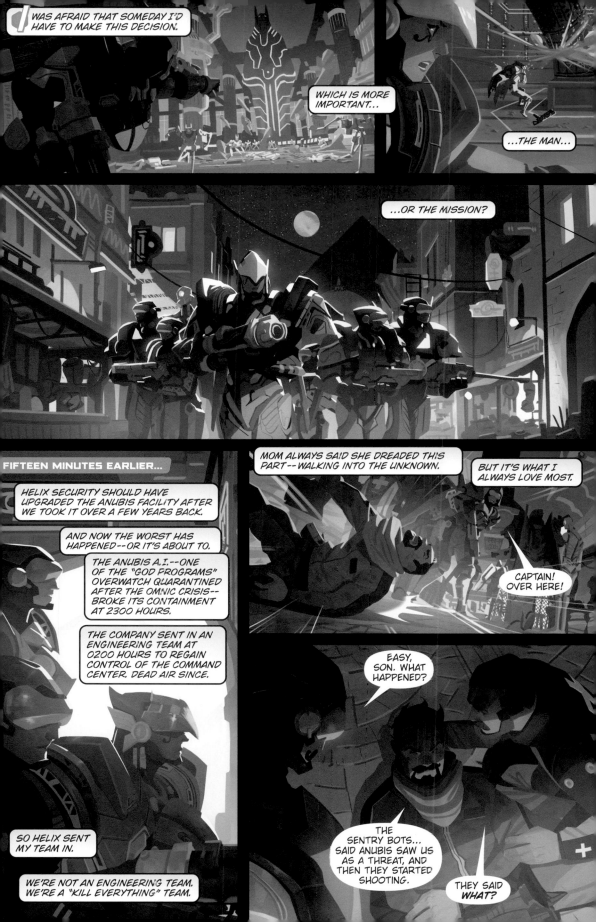

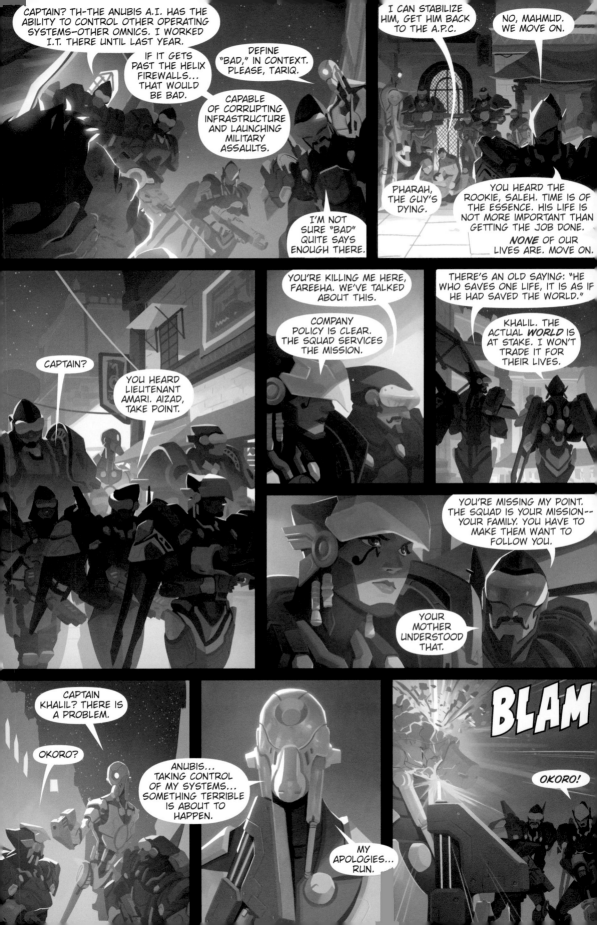

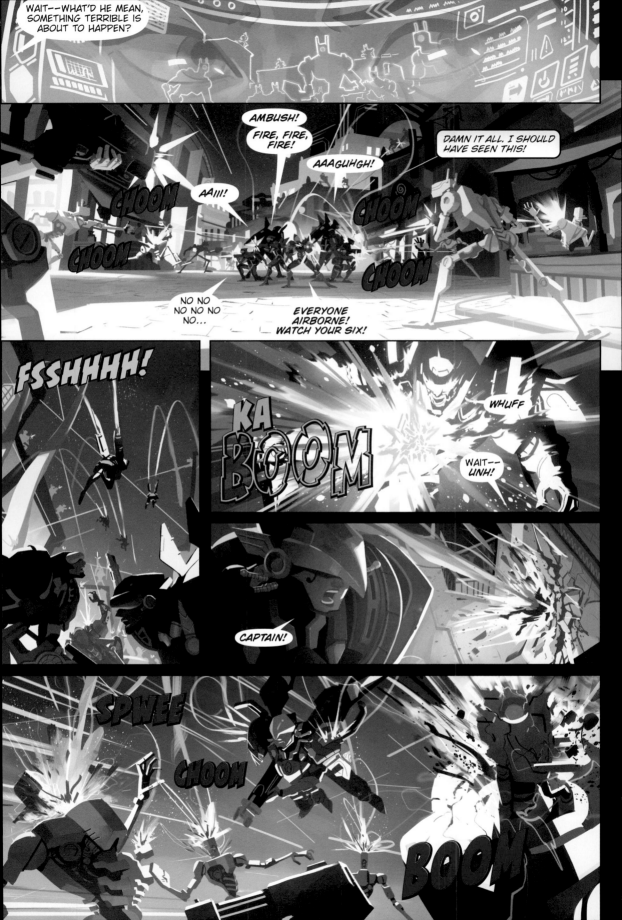

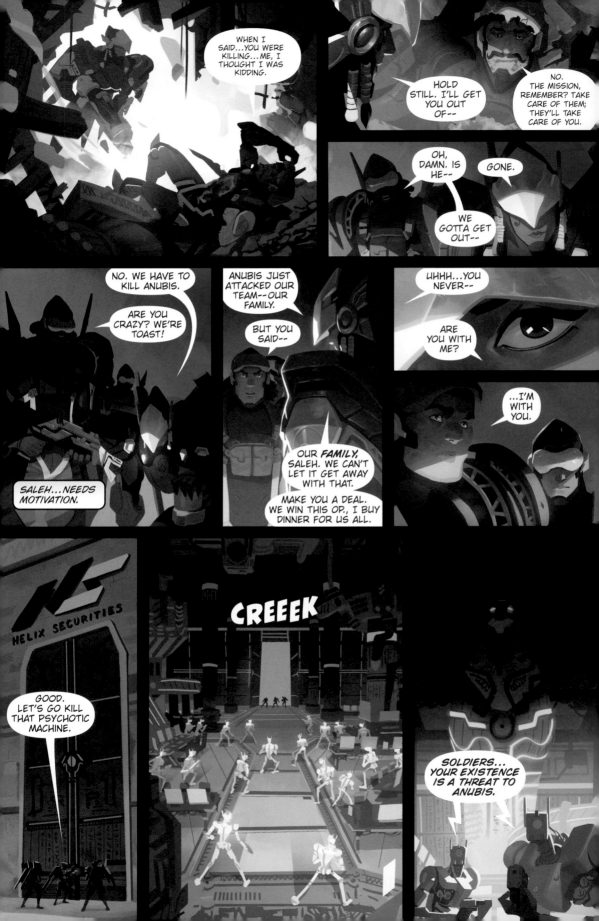

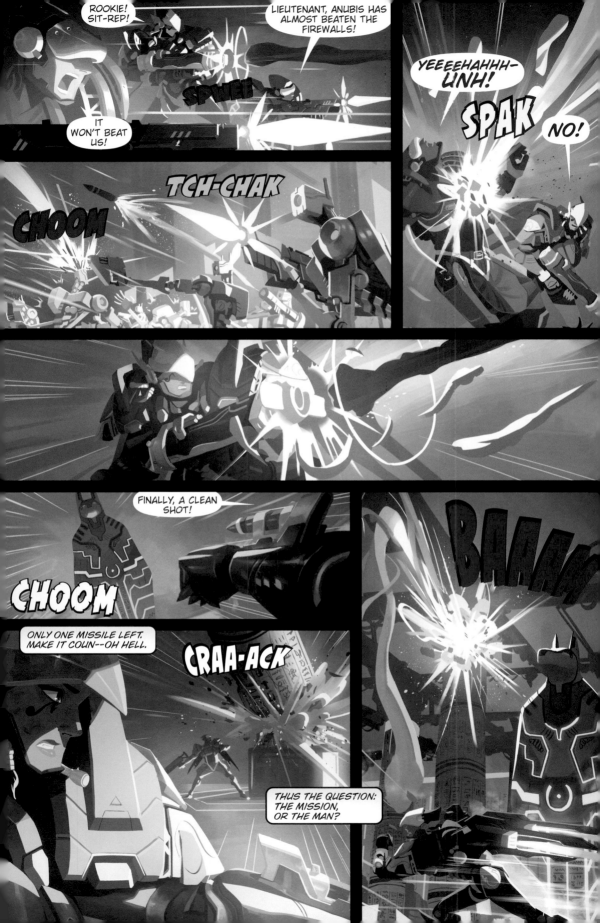

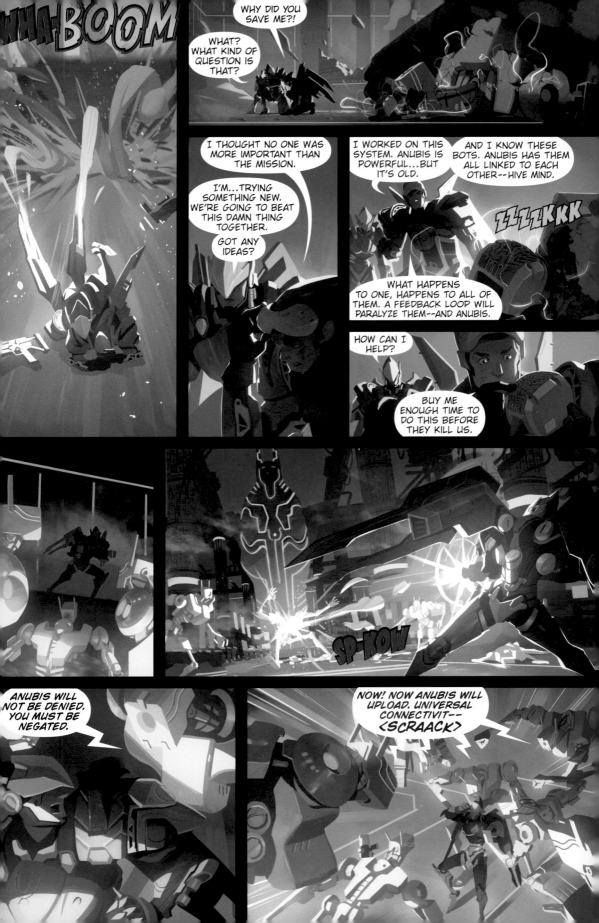

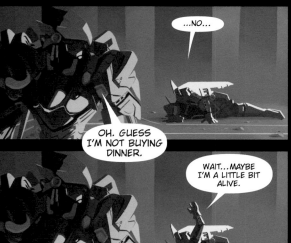

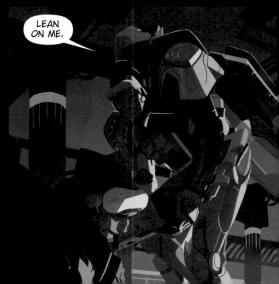

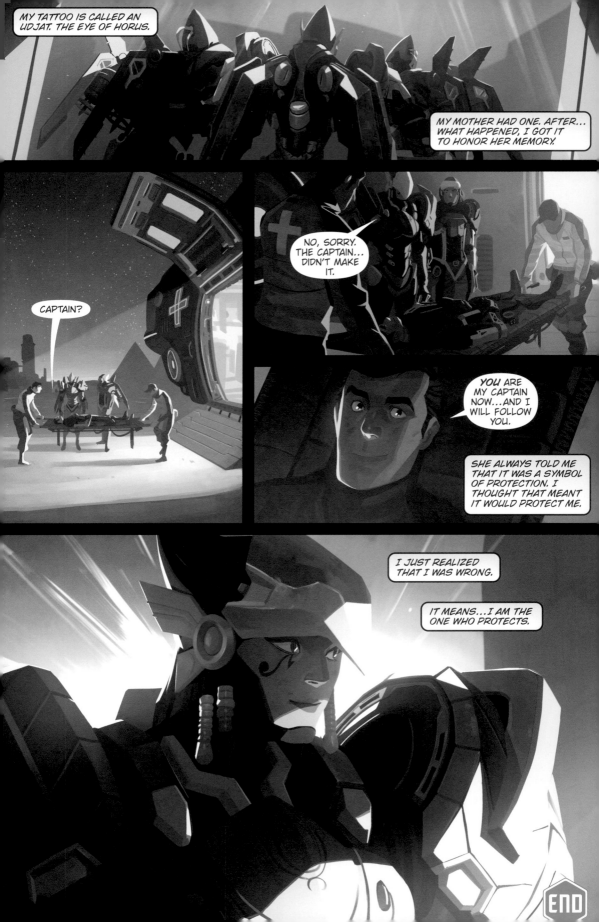

TORBJÖRN: *DESTROYER*

SCRIPT BY MICKY NEILSON | ART BY GRAY SHUKO | LETTERING BY RICHARD STARKINGS
AND Comicraft's JOHN ROSHELL AND JIMMY BETANCOURT

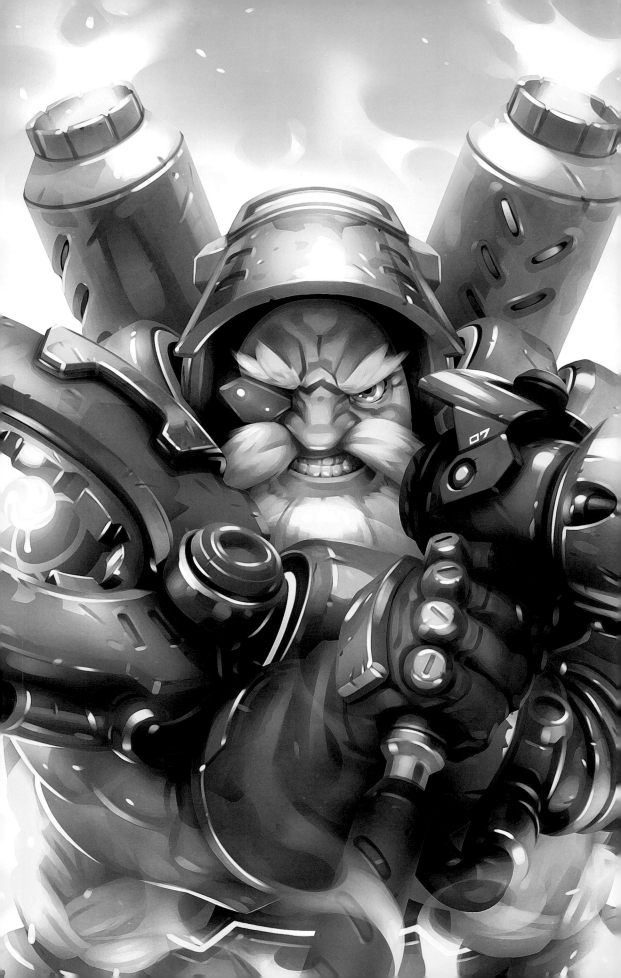

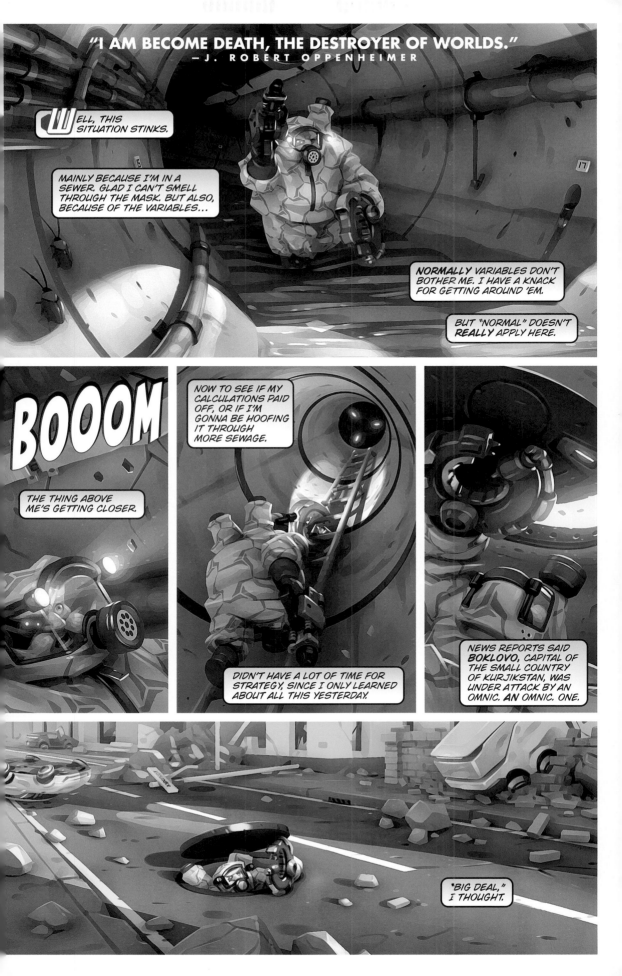

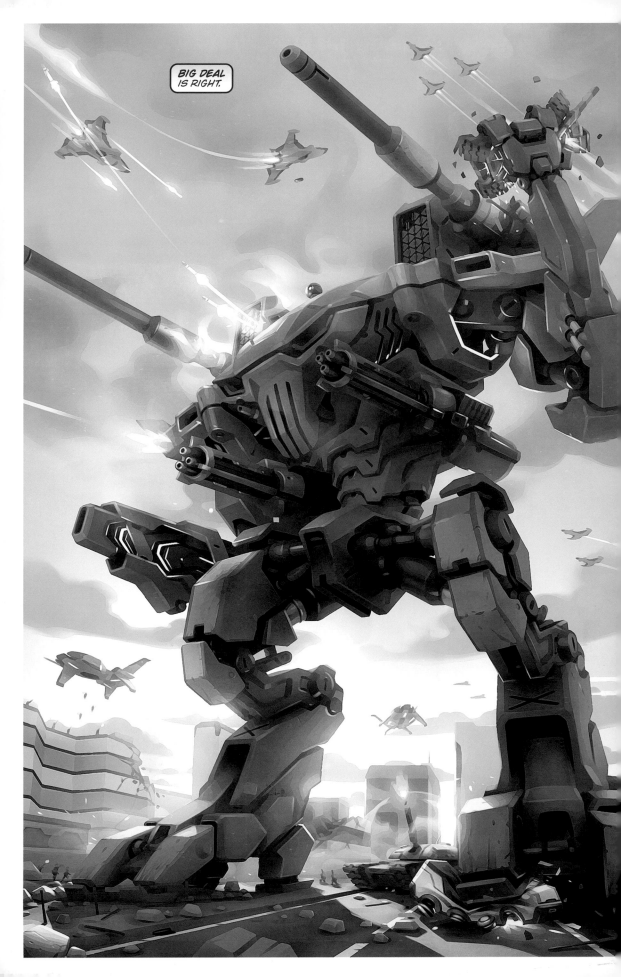

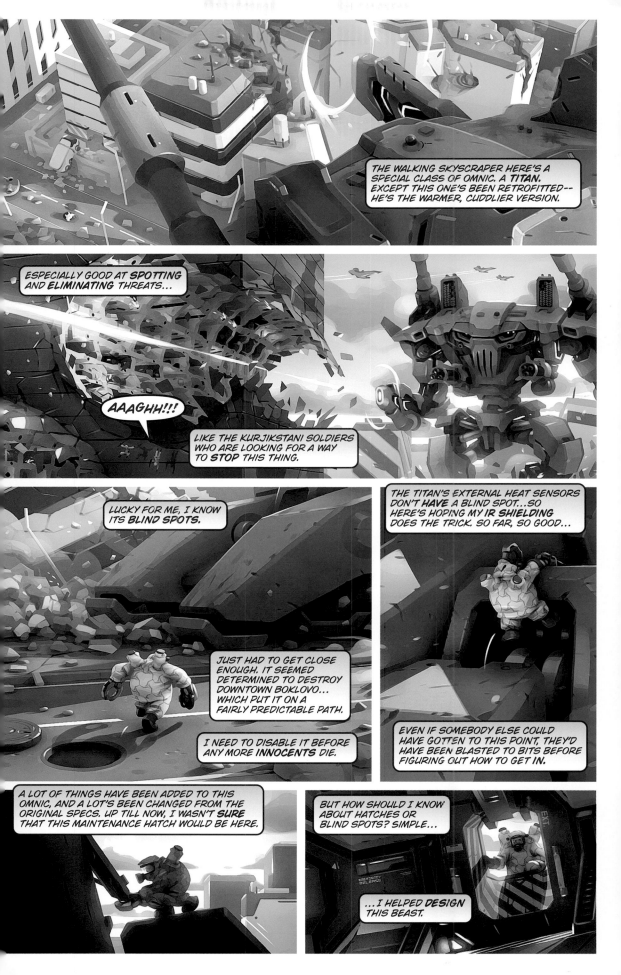

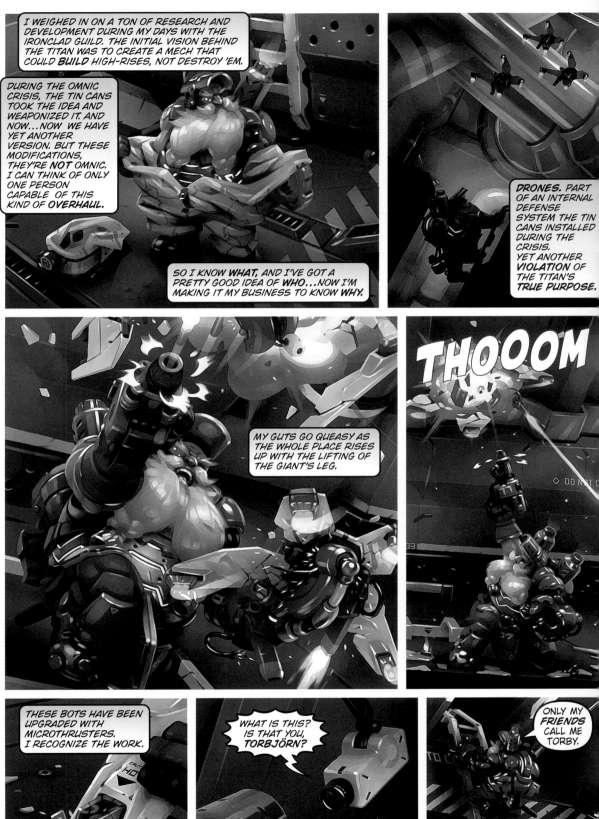

I WEIGHED IN ON A TON OF RESEARCH AND DEVELOPMENT DURING MY DAYS WITH THE IRONCLAD GUILD. THE INITIAL VISION BEHIND THE TITAN WAS TO CREATE A MECH THAT COULD **BUILD** HIGH-RISES, NOT DESTROY 'EM.

DURING THE OMNIC CRISIS, THE TIN CANS TOOK THE IDEA AND WEAPONIZED IT. AND NOW...NOW WE HAVE YET ANOTHER VERSION. BUT THESE MODIFICATIONS, THEY'RE **NOT** OMNIC. I CAN THINK OF ONLY ONE PERSON CAPABLE OF THIS KIND OF **OVERHAUL**.

SO I KNOW **WHAT**, AND I'VE GOT A PRETTY GOOD IDEA OF **WHO**...NOW I'M MAKING IT MY BUSINESS TO KNOW WHY.

DRONES. PART OF AN INTERNAL DEFENSE SYSTEM THE TIN CANS INSTALLED DURING THE CRISIS. YET ANOTHER **VIOLATION** OF THE TITAN'S **TRUE PURPOSE.**

MY GUTS GO QUEASY AS THE WHOLE PLACE RISES UP WITH THE LIFTING OF THE GIANT'S LEG.

THOOOM

THESE BOTS HAVE BEEN UPGRADED WITH MICROTHRUSTERS. I RECOGNIZE THE WORK.

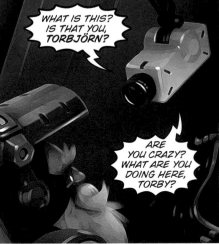

WHAT IS THIS? IS THAT YOU, **TORBJÖRN?**

ARE YOU CRAZY? WHAT ARE YOU DOING HERE, TORBY?

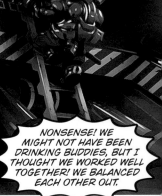

ONLY MY **FRIENDS** CALL ME TORBY.

NONSENSE! WE MIGHT NOT HAVE BEEN DRINKING BUDDIES, BUT I THOUGHT WE WORKED WELL TOGETHER! WE BALANCED EACH OTHER OUT.

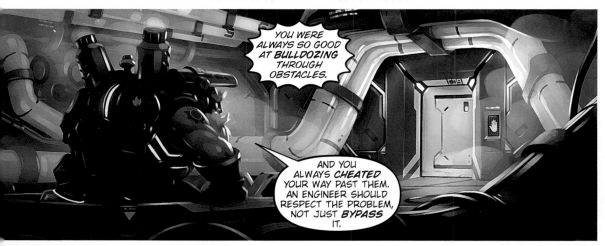

YOU WERE ALWAYS SO GOOD AT **BULLDOZING** THROUGH OBSTACLES.

AND YOU ALWAYS **CHEATED** YOUR WAY PAST THEM. AN ENGINEER SHOULD RESPECT THE PROBLEM, NOT JUST **BYPASS** IT.

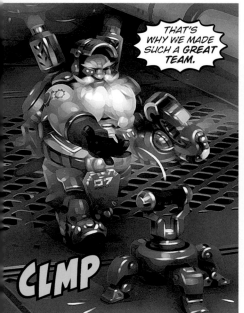

THAT'S WHY WE MADE SUCH A **GREAT** TEAM.

CLMP

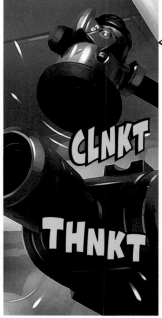

CLNKT

THNKT

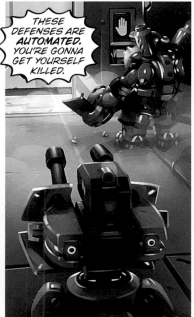

THESE DEFENSES ARE **AUTOMATED.** YOU'RE GONNA GET YOURSELF KILLED.

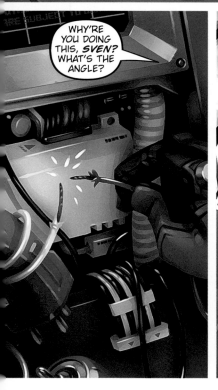

WHY'RE YOU DOING THIS, **SVEN?** WHAT'S THE ANGLE?

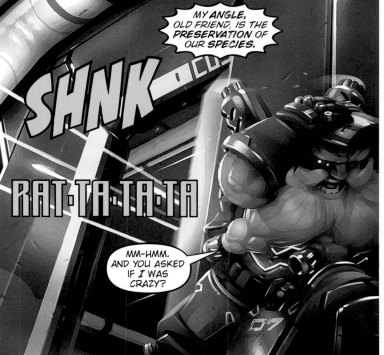

MY ANGLE, OLD FRIEND, IS THE **PRESERVATION** OF OUR **SPECIES.**

SHNK

RAT·TA·TA·TA

MM-HMM. AND YOU ASKED IF **I** WAS CRAZY?

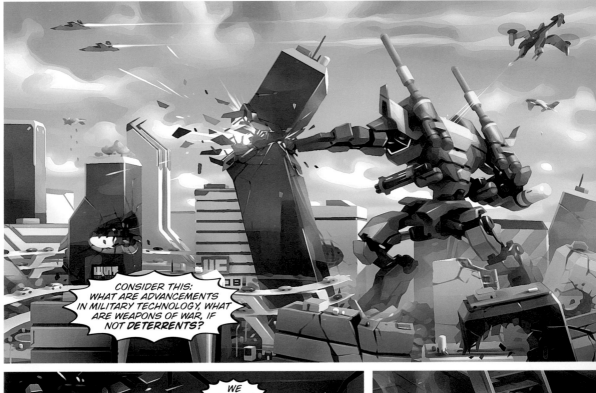

CONSIDER THIS: WHAT ARE ADVANCEMENTS IN MILITARY TECHNOLOGY, WHAT ARE WEAPONS OF WAR, IF NOT *DETERRENTS*?

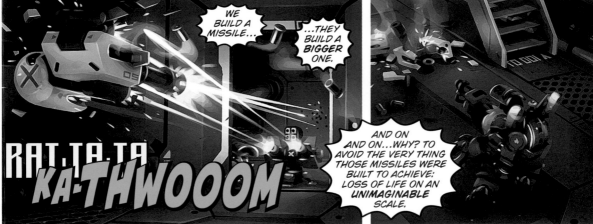

WE BUILD A MISSILE...

...THEY BUILD A *BIGGER* ONE.

RAT.TA.TA KA-THWOOOM

AND ON AND ON...WHY? TO AVOID THE VERY THING THOSE MISSILES WERE BUILT TO ACHIEVE: LOSS OF LIFE ON AN *UNIMAGINABLE* SCALE.

WHAT WORLD POWER WOULDN'T *THINK TWICE* BEFORE ATTACKING A FOE CAPABLE OF *OBLITERATING* IT?

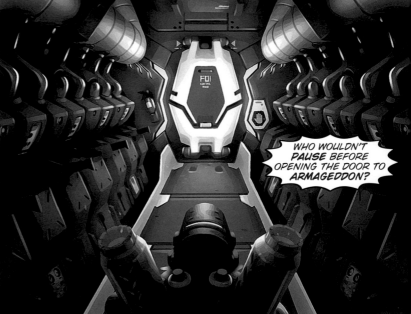

WHO WOULDN'T *PAUSE* BEFORE OPENING THE DOOR TO ARMAGEDDON?

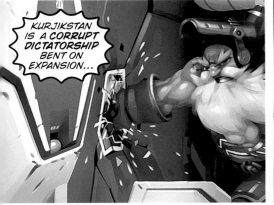

KURJIKSTAN IS A *CORRUPT DICTATORSHIP* BENT ON EXPANSION...

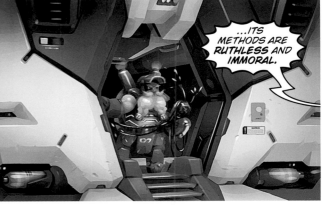

...ITS METHODS ARE *RUTHLESS AND IMMORAL.*

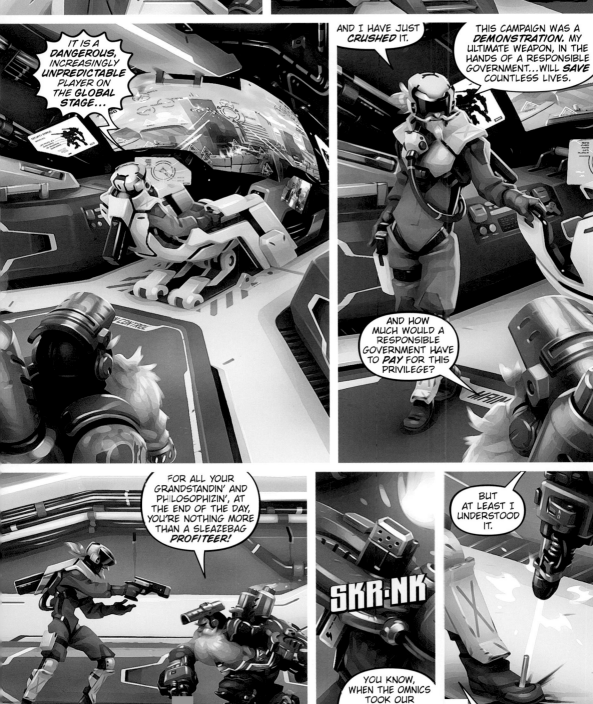

IT IS A *DANGEROUS,* INCREASINGLY *UNPREDICTABLE* PLAYER ON THE *GLOBAL STAGE...*

AND I HAVE JUST *CRUSHED* IT.

THIS CAMPAIGN WAS A *DEMONSTRATION.* MY ULTIMATE WEAPON, IN THE HANDS OF A *RESPONSIBLE GOVERNMENT...*WILL *SAVE* COUNTLESS LIVES.

AND HOW MUCH WOULD A RESPONSIBLE GOVERNMENT HAVE TO *PAY* FOR THIS PRIVILEGE?

FOR ALL YOUR *GRANDSTANDIN'* AND *PHILOSOPHIZIN',* AT THE END OF THE DAY, YOU'RE NOTHING MORE THAN A SLEAZEBAG *PROFITEER!*

SKR-NK

YOU KNOW, WHEN THE OMNICS TOOK OUR TECHNOLOGY AND TWISTED IT TO THEIR NEEDS, IT INFURIATED ME...

BUT AT LEAST I UNDERSTOOD IT.

AARRGGH!!

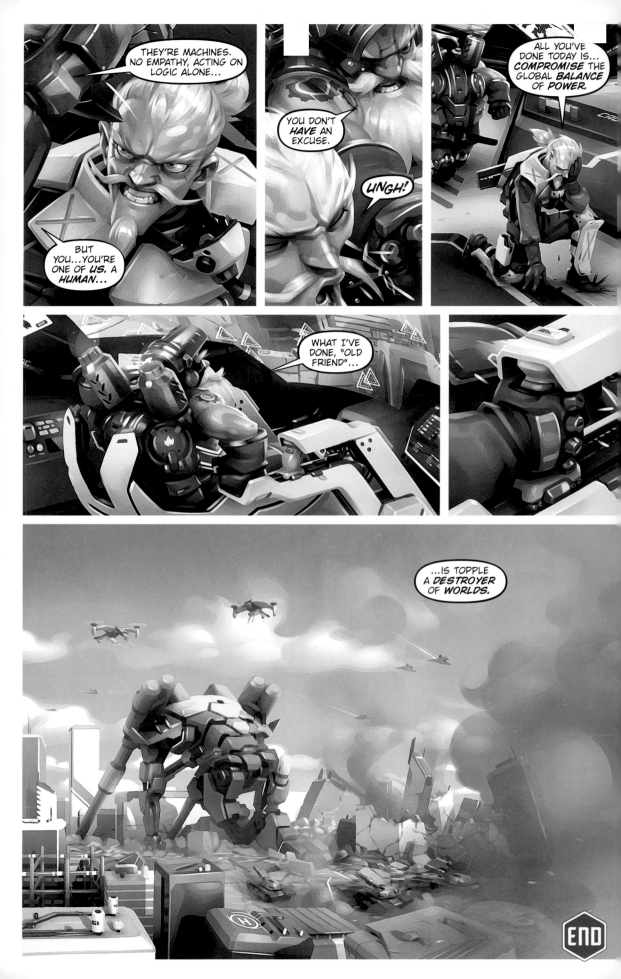

ANA: *LEGACY*

SCRIPT BY ANDREW ROBINSON | ART BY BENGAL | LETTERING BY RICHARD STARKINGS
AND Comicraft's JOHN ROSHELL, JIMMY BETANCOURT, AND ALBERT DESCHESNE

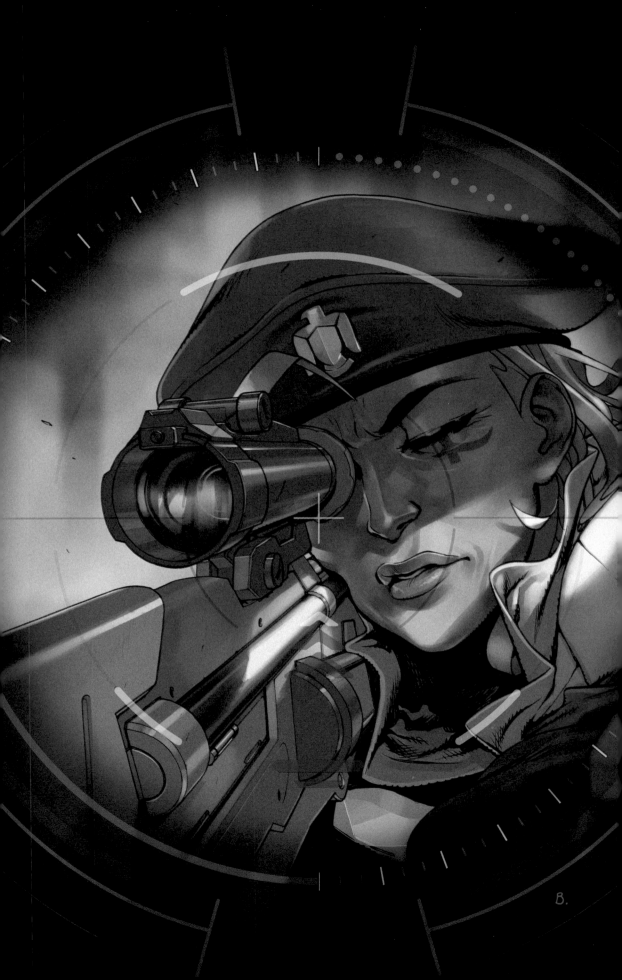

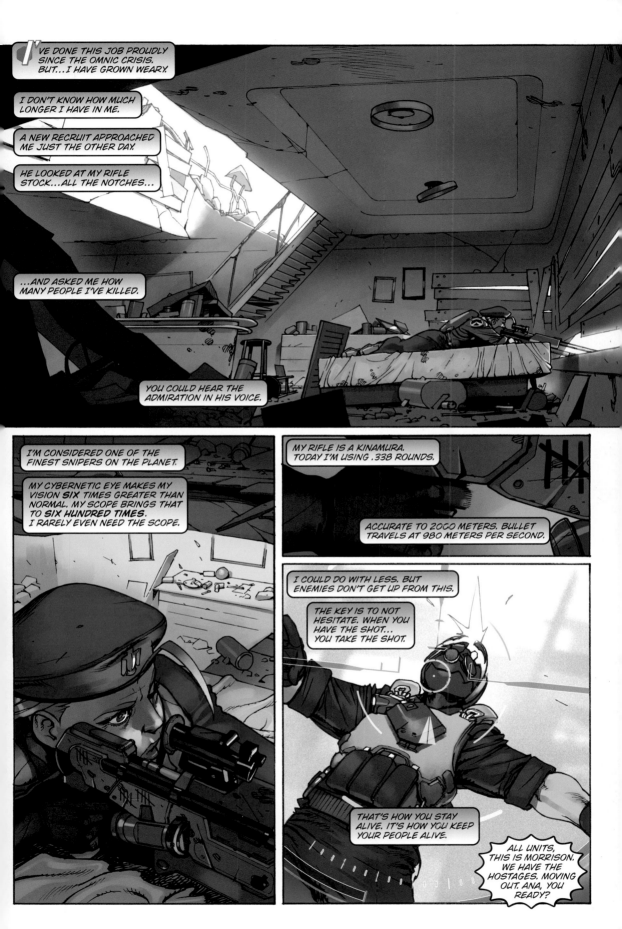

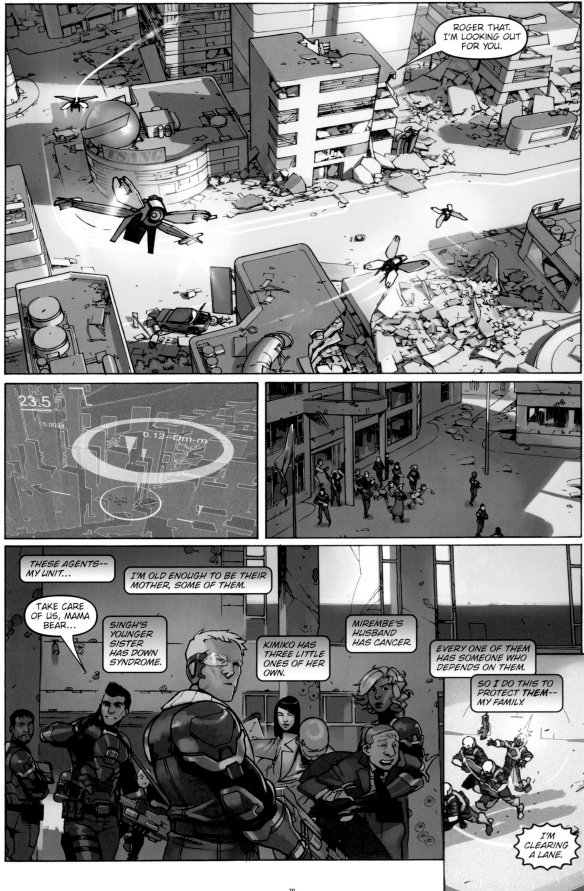

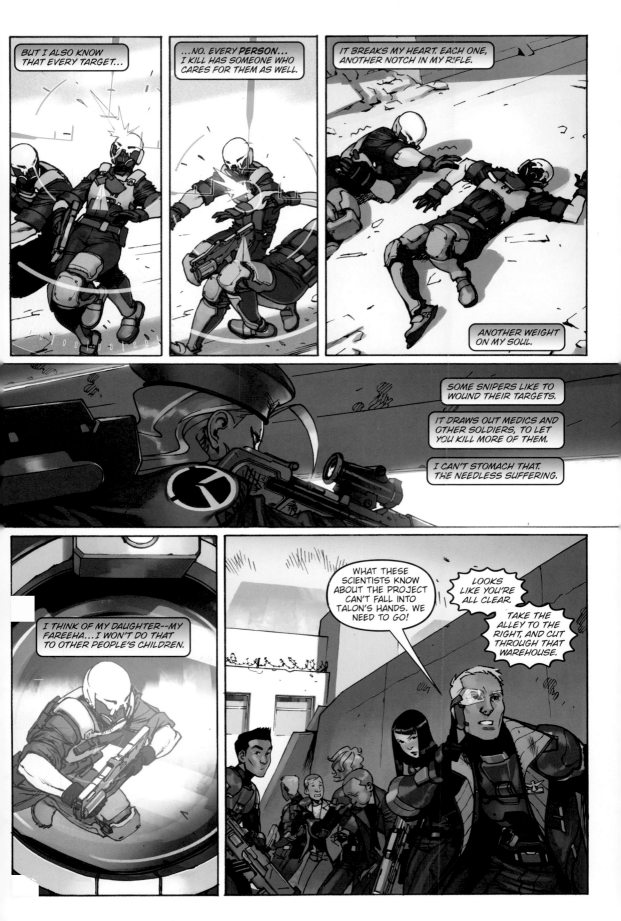

BUT I ALSO KNOW THAT EVERY TARGET...

...NO. EVERY *PERSON*... I KILL HAS SOMEONE WHO CARES FOR THEM AS WELL.

IT BREAKS MY HEART. EACH ONE, ANOTHER NOTCH IN MY RIFLE.

ANOTHER WEIGHT ON MY SOUL.

SOME SNIPERS LIKE TO WOUND THEIR TARGETS.

IT DRAWS OUT MEDICS AND OTHER SOLDIERS, TO LET YOU KILL MORE OF THEM.

I CAN'T STOMACH THAT. THE NEEDLESS SUFFERING.

I THINK OF MY DAUGHTER--MY FAREEHA...I WON'T DO THAT TO OTHER PEOPLE'S CHILDREN.

WHAT THESE SCIENTISTS KNOW ABOUT THE PROJECT CAN'T FALL INTO TALON'S HANDS. WE NEED TO GO!

LOOKS LIKE YOU'RE ALL CLEAR.

TAKE THE ALLEY TO THE RIGHT, AND CUT THROUGH THAT WAREHOUSE.

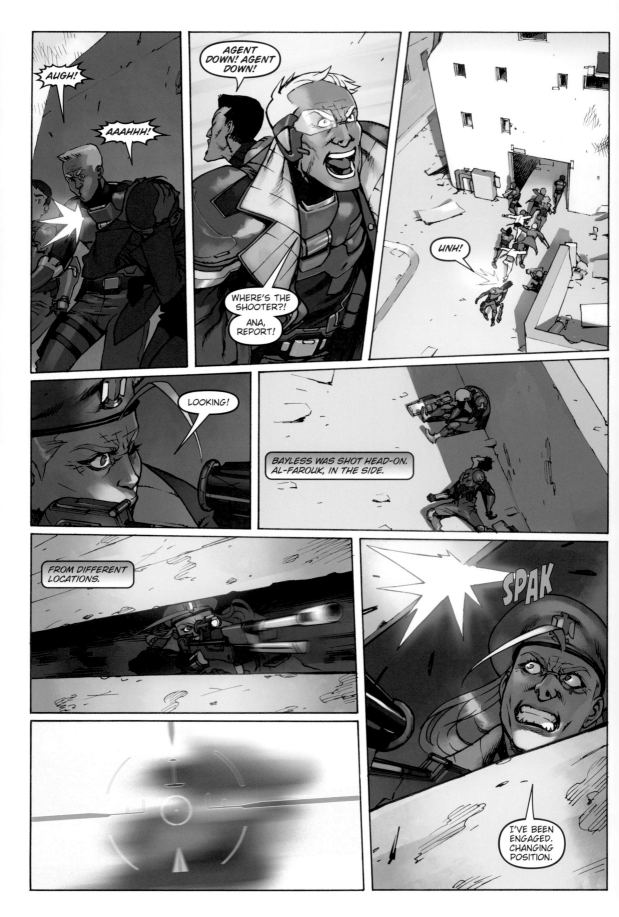

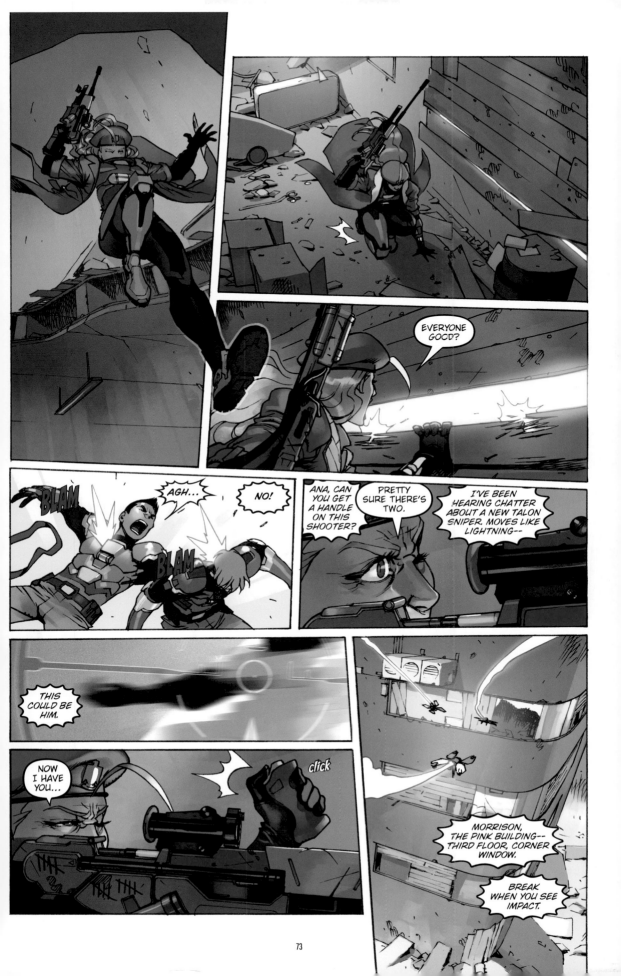

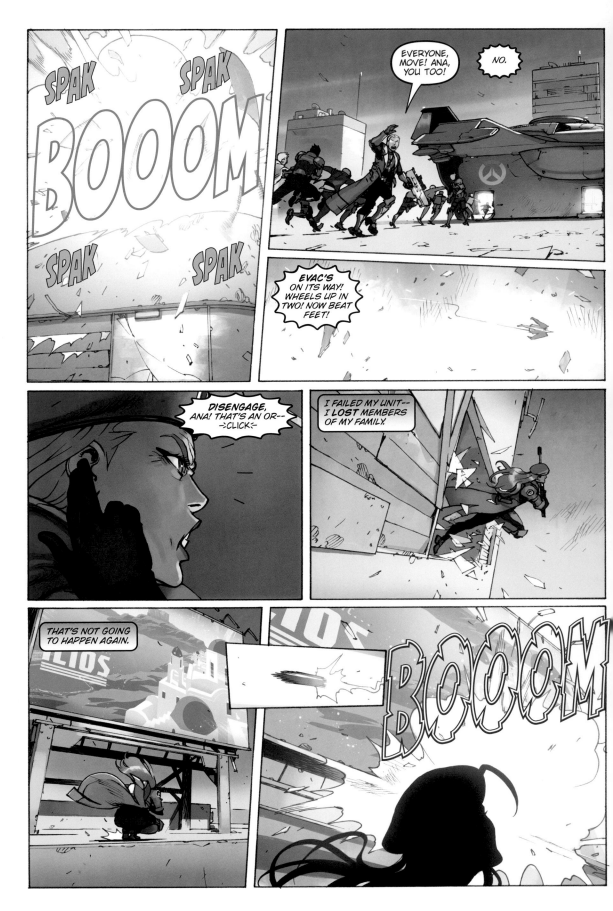

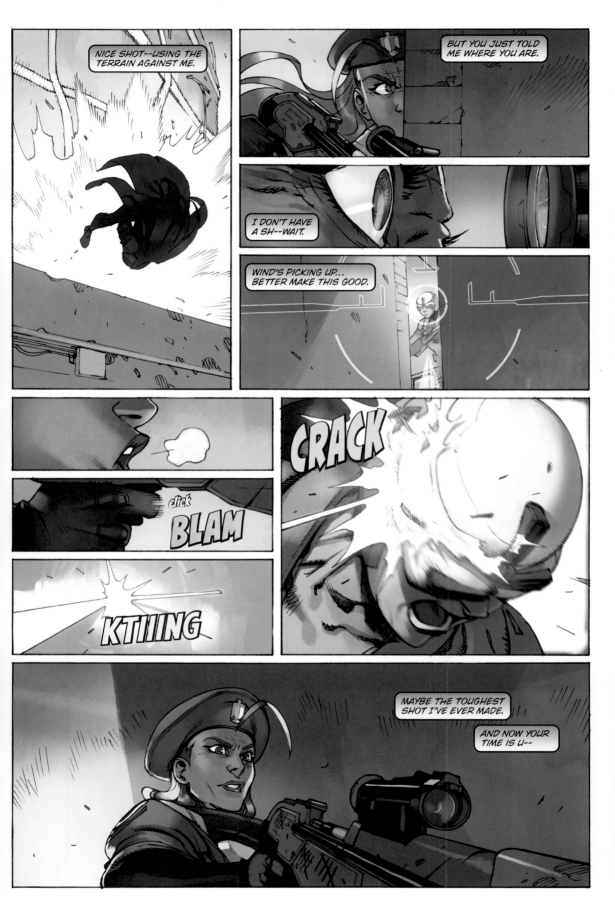

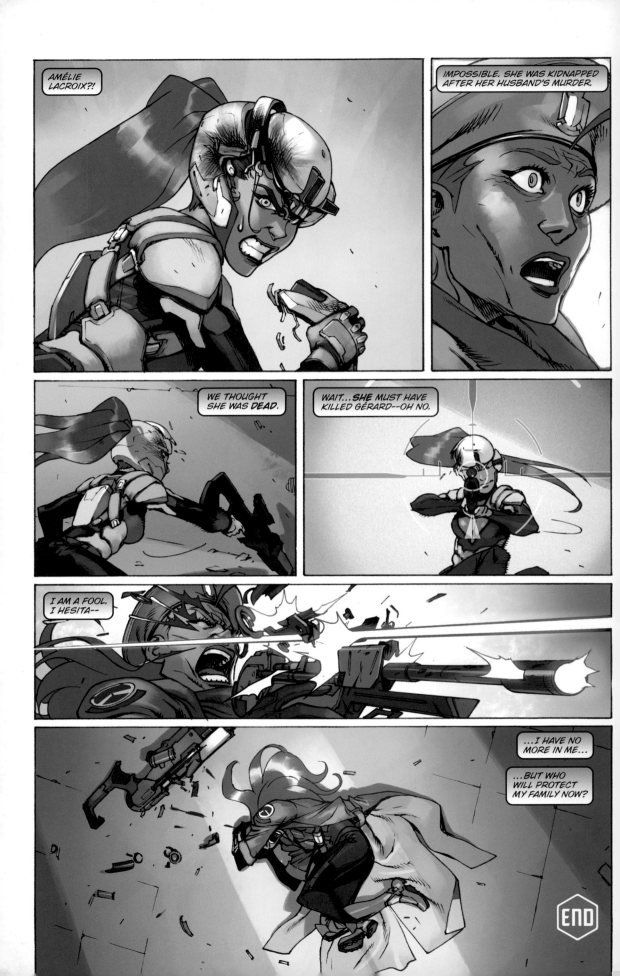

ANA: *OLD SOLDIERS*

SCRIPT BY MICHAEL CHU | ART BY BENGAL | LETTERING BY RICHARD STARKINGS
AND Comicraft's JOHN ROSHELL, JIMMY BETANCOURT, AND ALBERT DESCHESNE

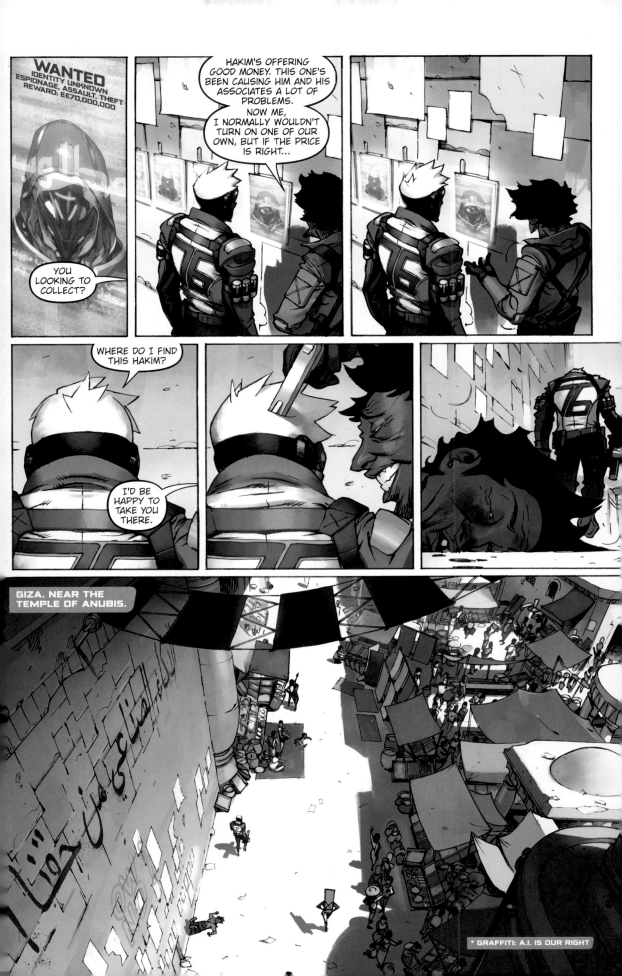

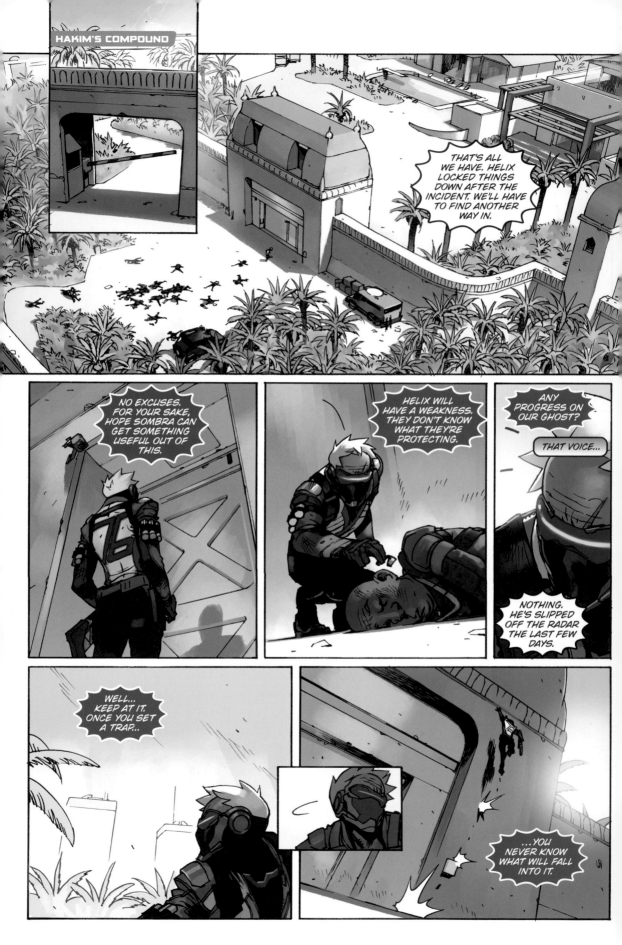

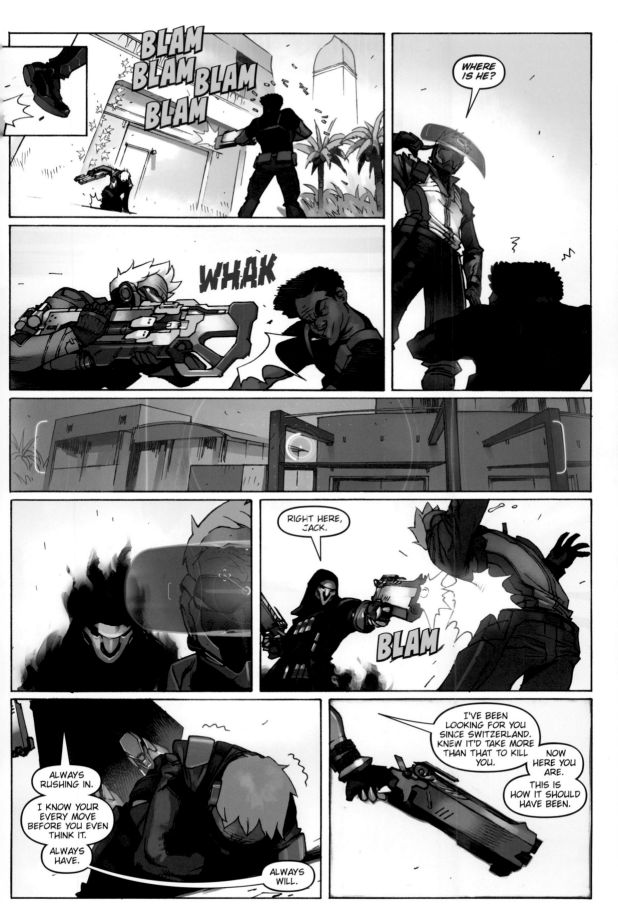

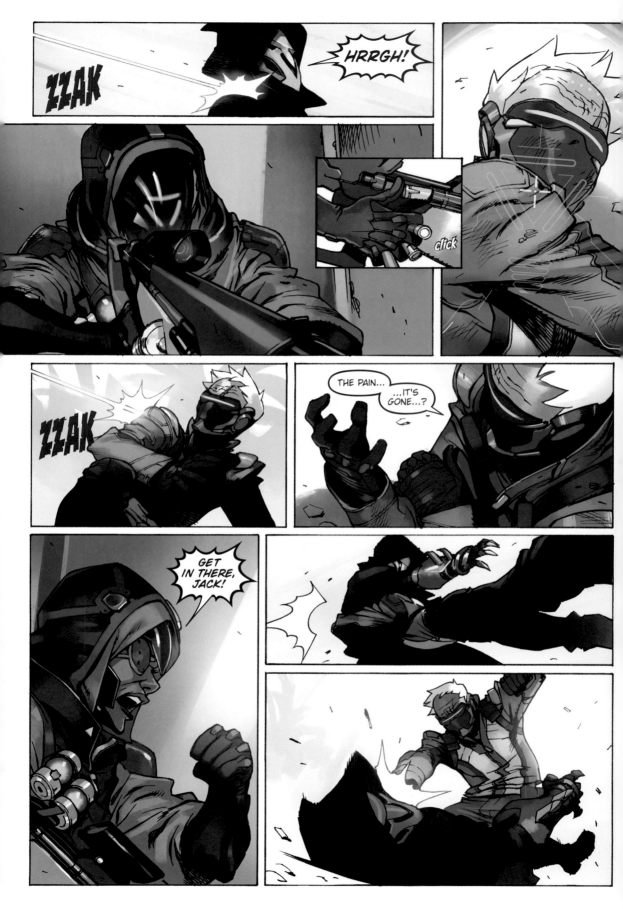

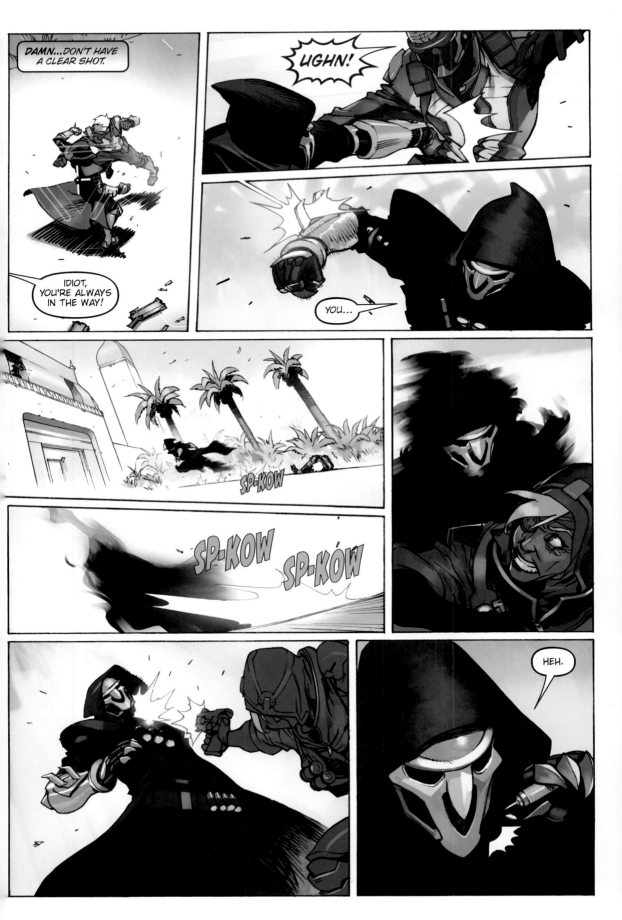

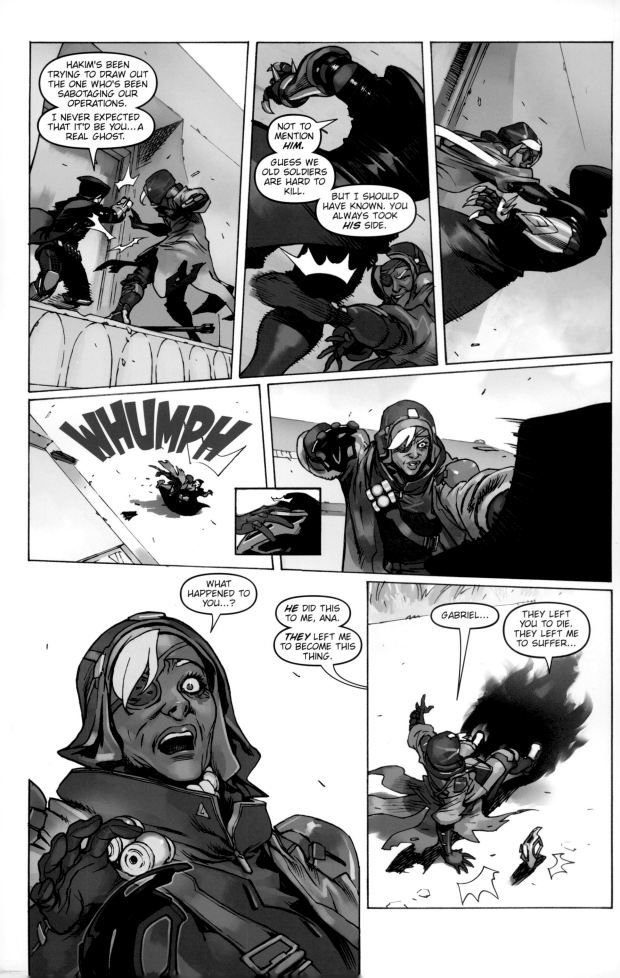

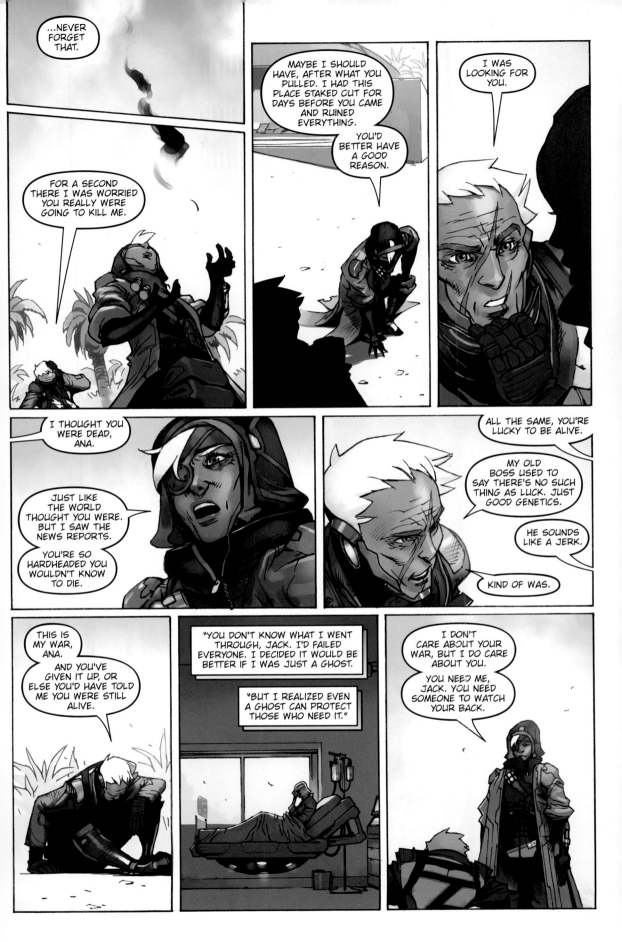

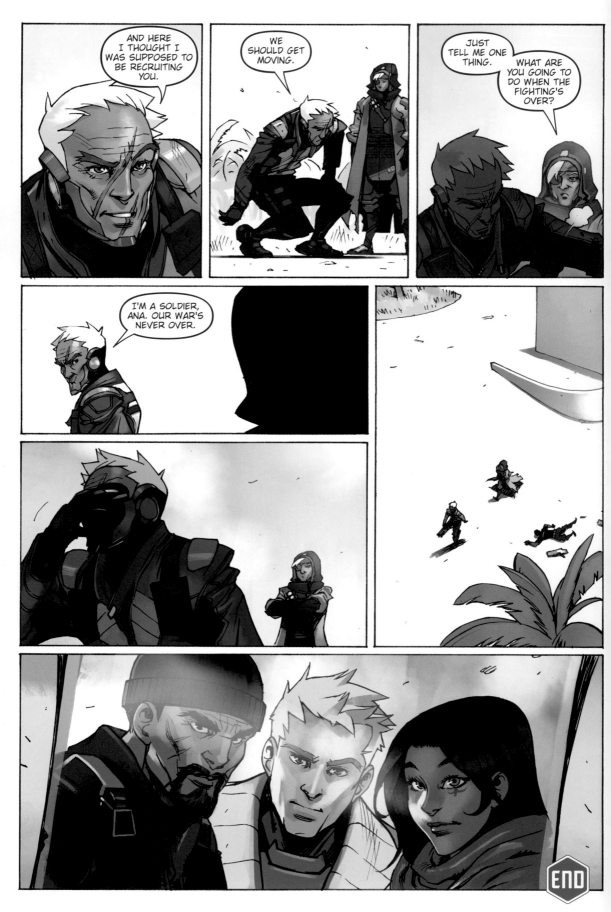

JUNKENSTEIN

PLOT BY MICHAEL CHU | SCRIPT BY MATT BURNS | ART BY GRAY SHUKO

LETTERING BY RICHARD STARKINGS AND Comicraft's JOHN ROSHELL, JIMMY BETANCOURT, AND ALBERT DESCHESNE

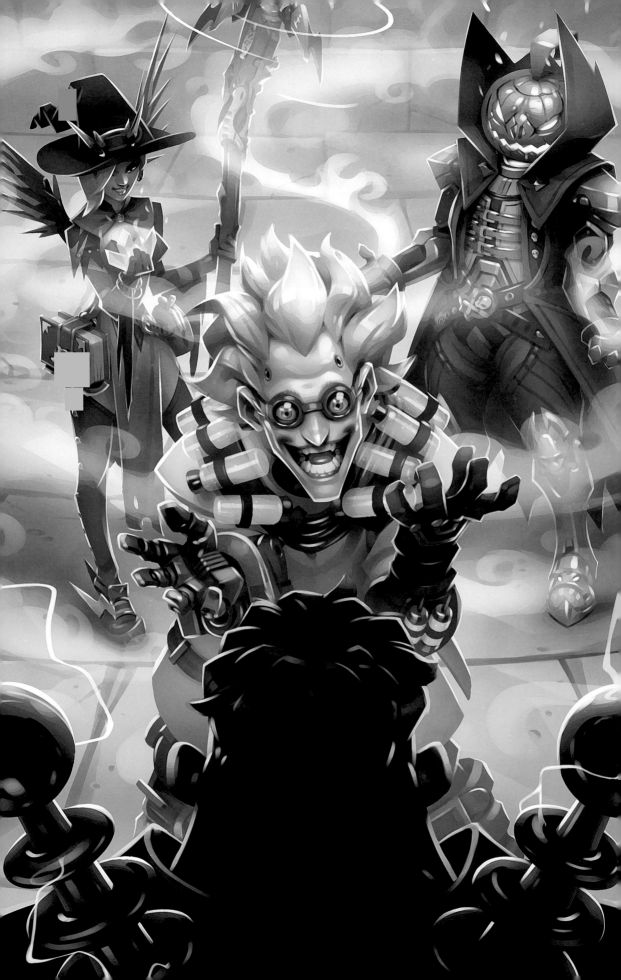

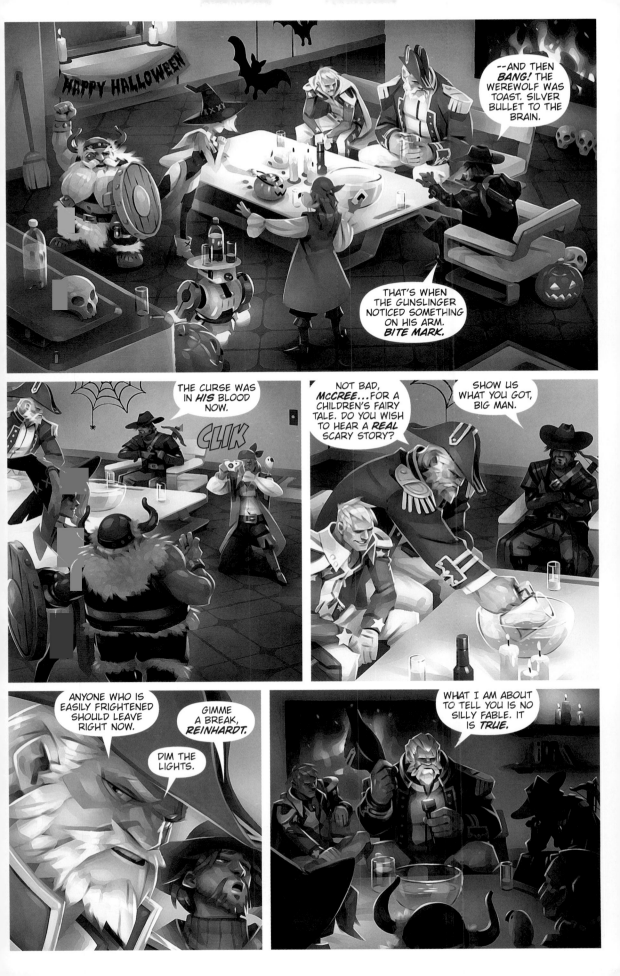

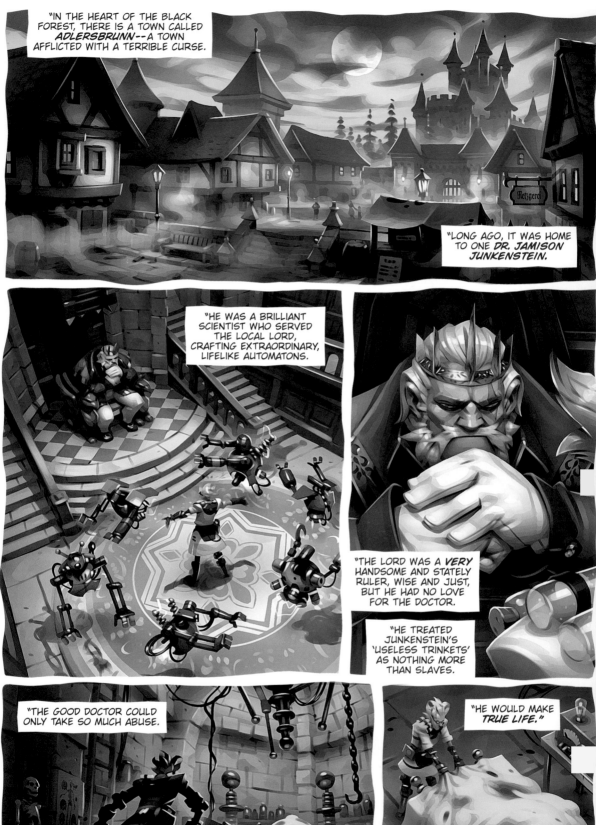

"IN THE HEART OF THE BLACK FOREST, THERE IS A TOWN CALLED **ADLERSBRUNN**—A TOWN AFFLICTED WITH A TERRIBLE CURSE.

"LONG AGO, IT WAS HOME TO ONE **DR. JAMISON JUNKENSTEIN.**

"HE WAS A BRILLIANT SCIENTIST WHO SERVED THE LOCAL LORD, CRAFTING EXTRAORDINARY, LIFELIKE AUTOMATONS.

"THE LORD WAS A **VERY** HANDSOME AND STATELY RULER, WISE AND JUST, BUT HE HAD NO LOVE FOR THE DOCTOR.

"HE TREATED JUNKENSTEIN'S 'USELESS TRINKETS' AS NOTHING MORE THAN SLAVES."

"THE GOOD DOCTOR COULD ONLY TAKE SO MUCH ABUSE.

"HE WOULD EARN THE RESPECT OF THE LORD AND THE TOWNSFOLK BY MAKING A CREATURE THAT COULD THINK FOR ITSELF.

"HE WOULD MAKE **TRUE LIFE.**"

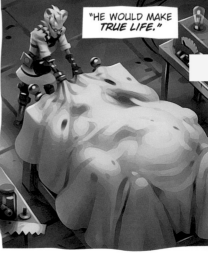

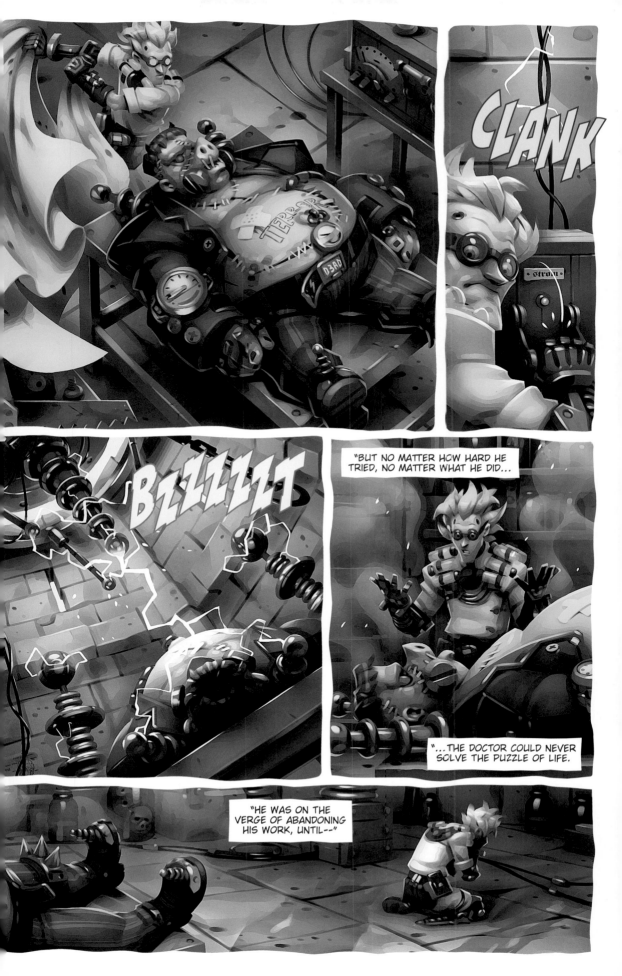

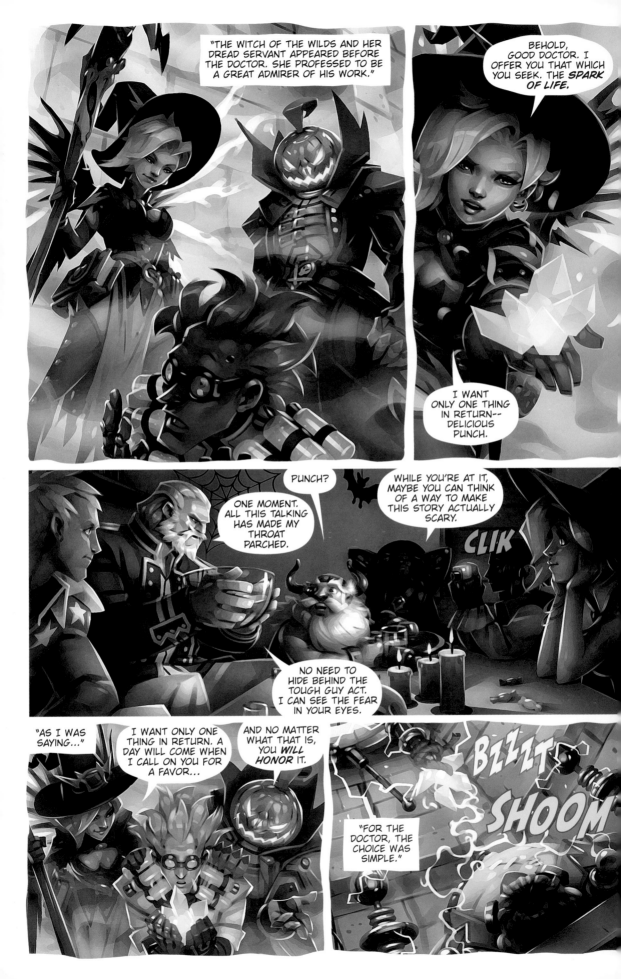

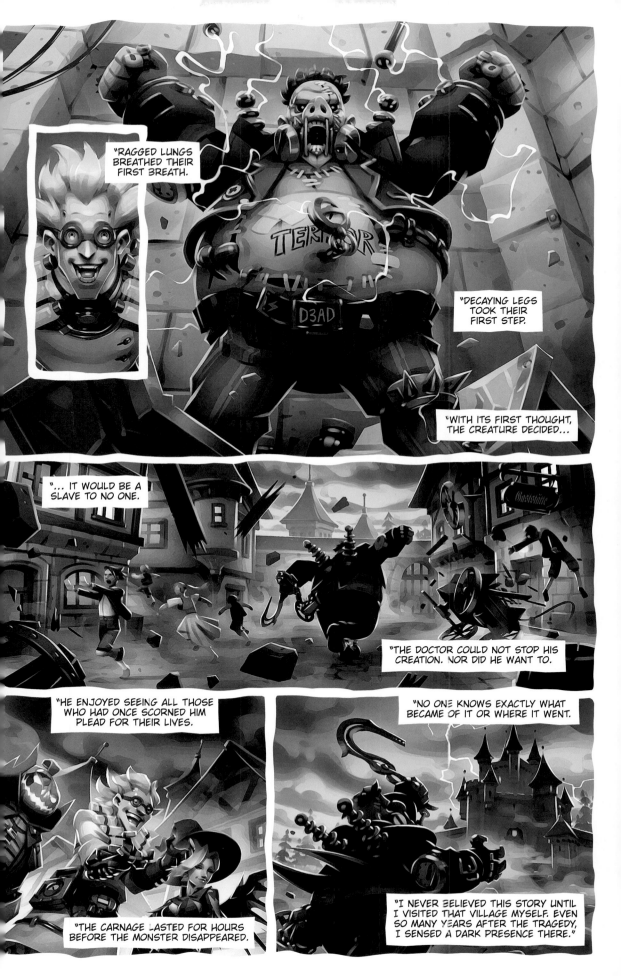

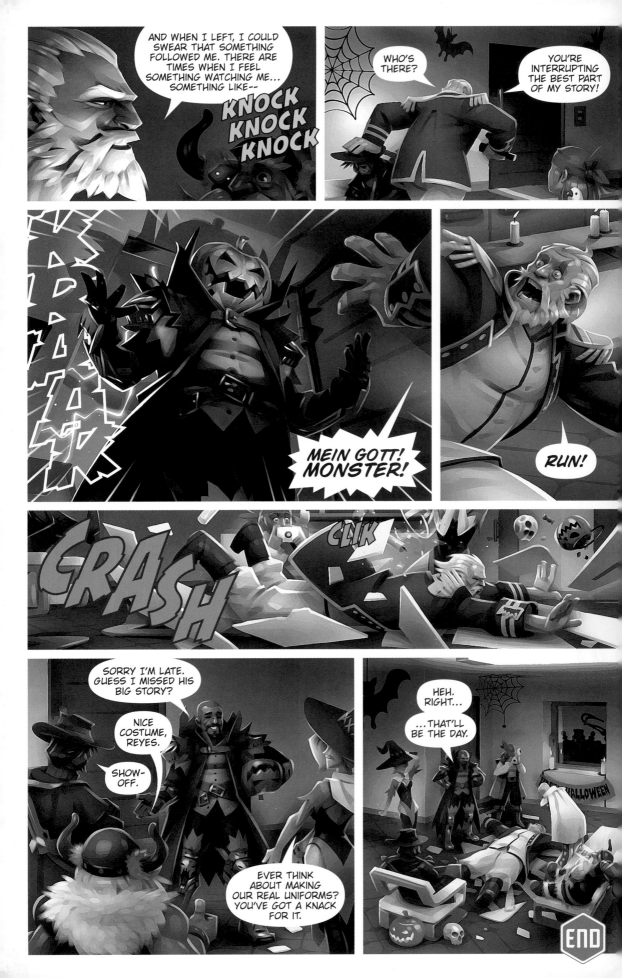

END

REFLECTIONS

SCRIPT BY MICHAEL CHU | ART BY MIKI MONTLLÓ

LETTERING BY RICHARD STARKINGS AND Comicraft's JOHN ROSHELL, JIMMY BETANCOURT, AND ALBERT DESCHESNE

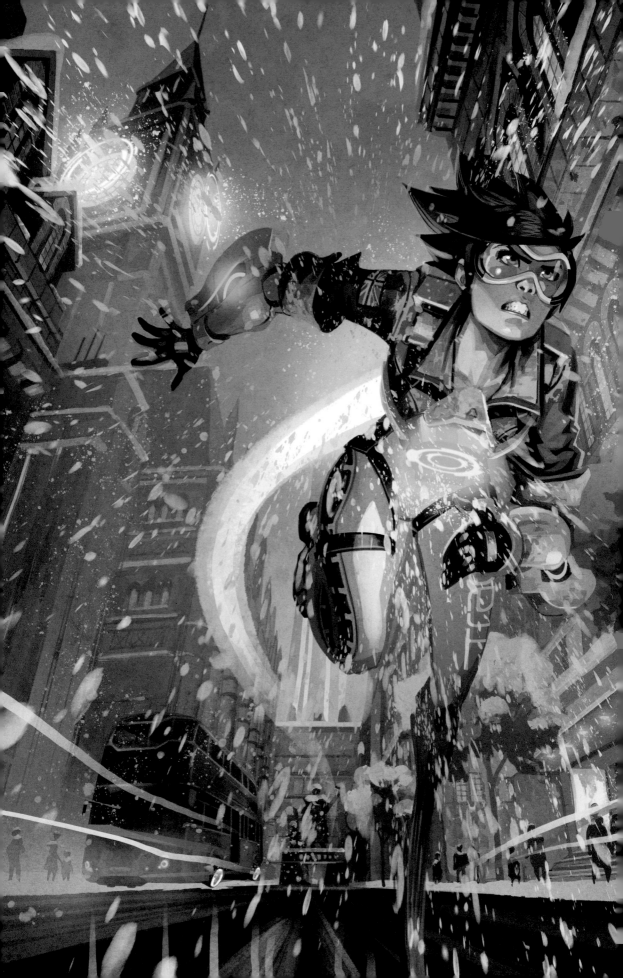

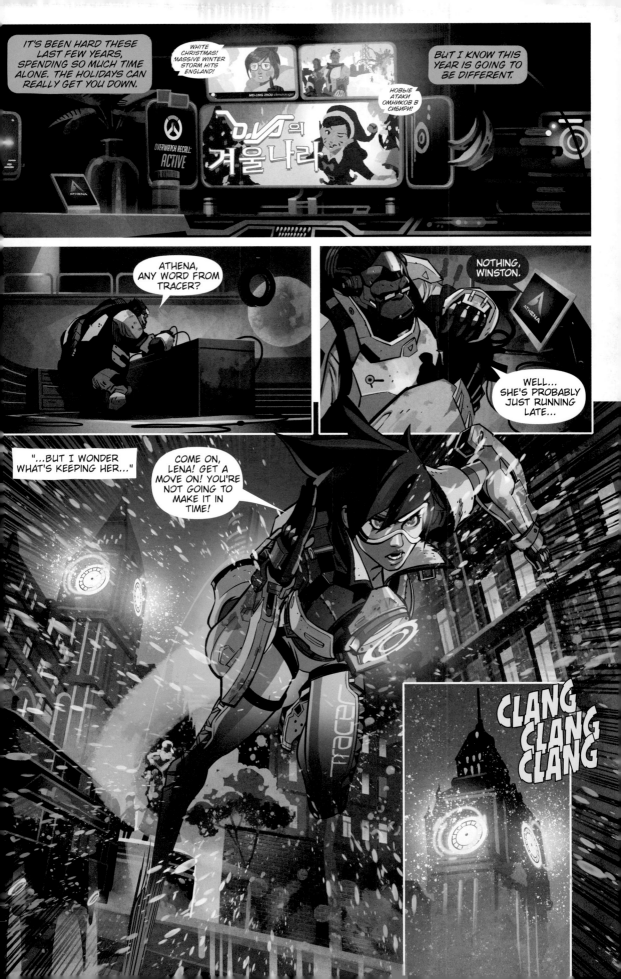

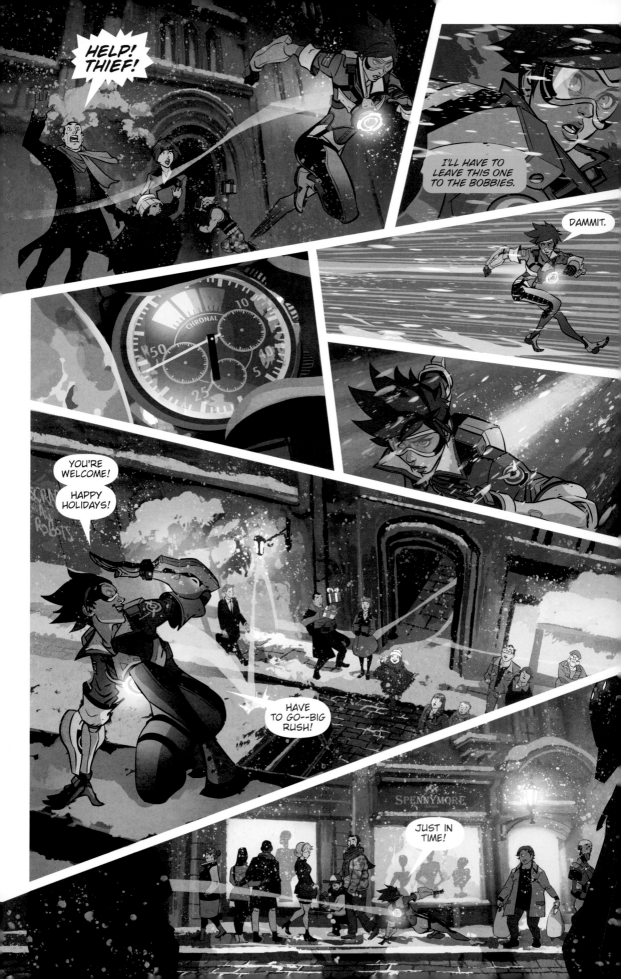

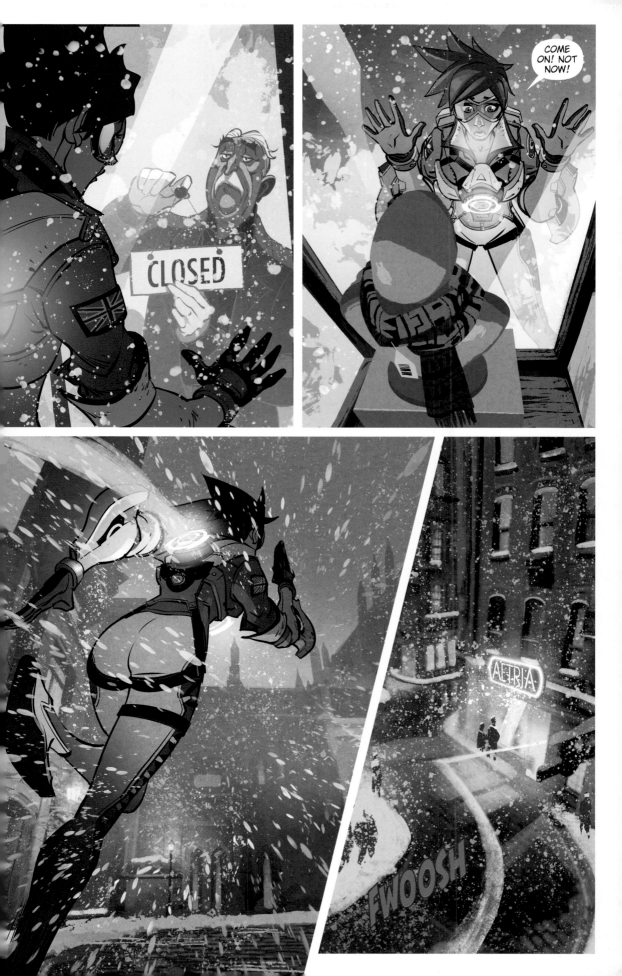

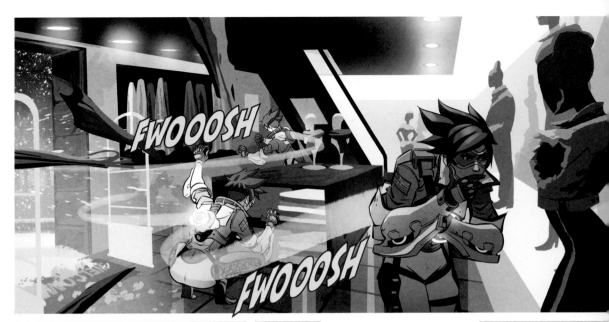

FWOOOSH

FWOOOSH

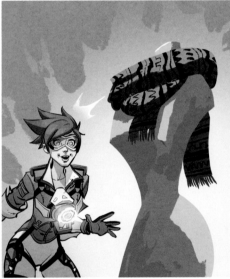

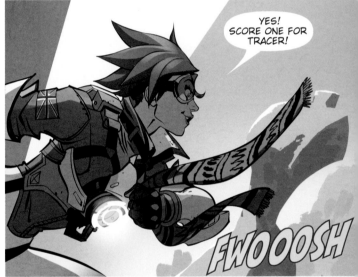

YES! SCORE ONE FOR TRACER!

FWOOOSH

-≻SIGH≺-

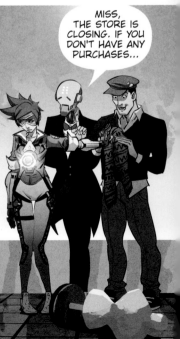

MISS, THE STORE IS CLOSING. IF YOU DON'T HAVE ANY PURCHASES...

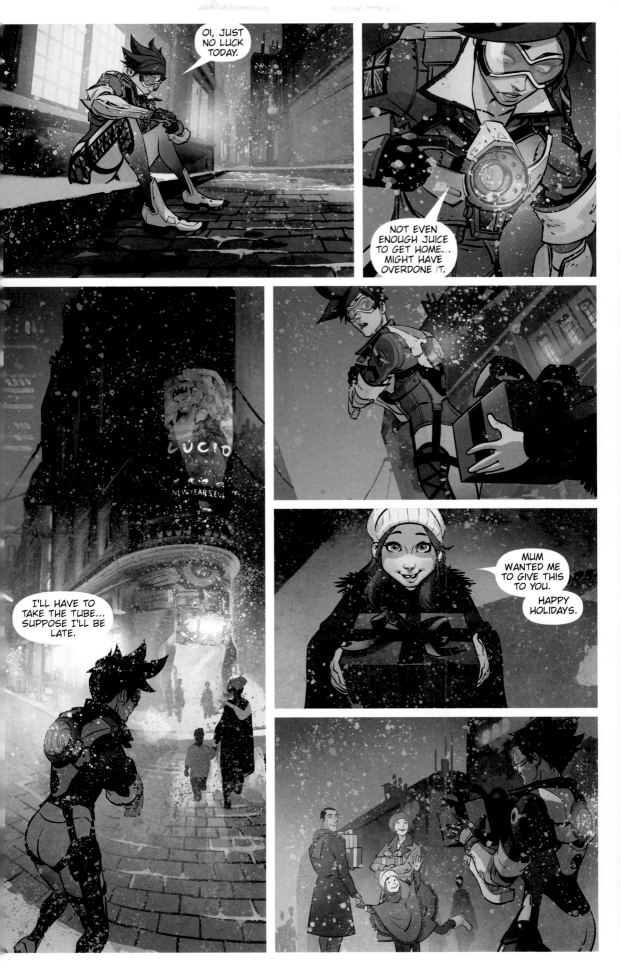

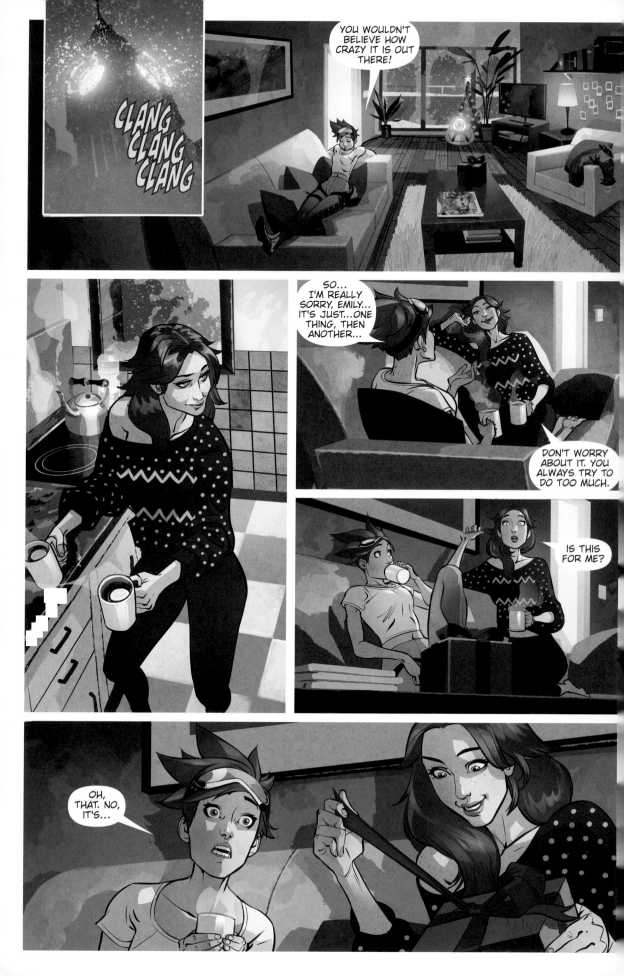

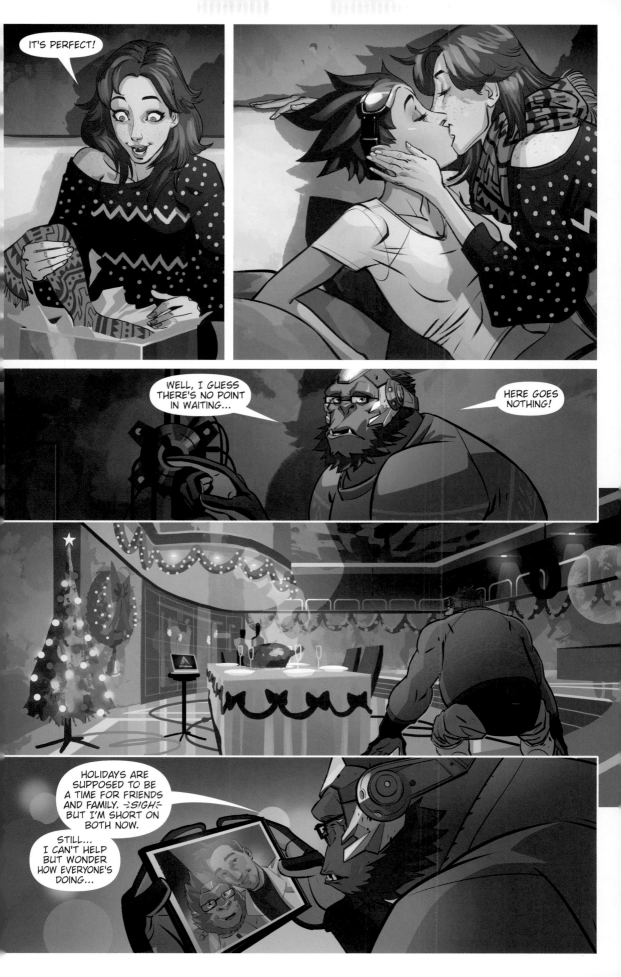

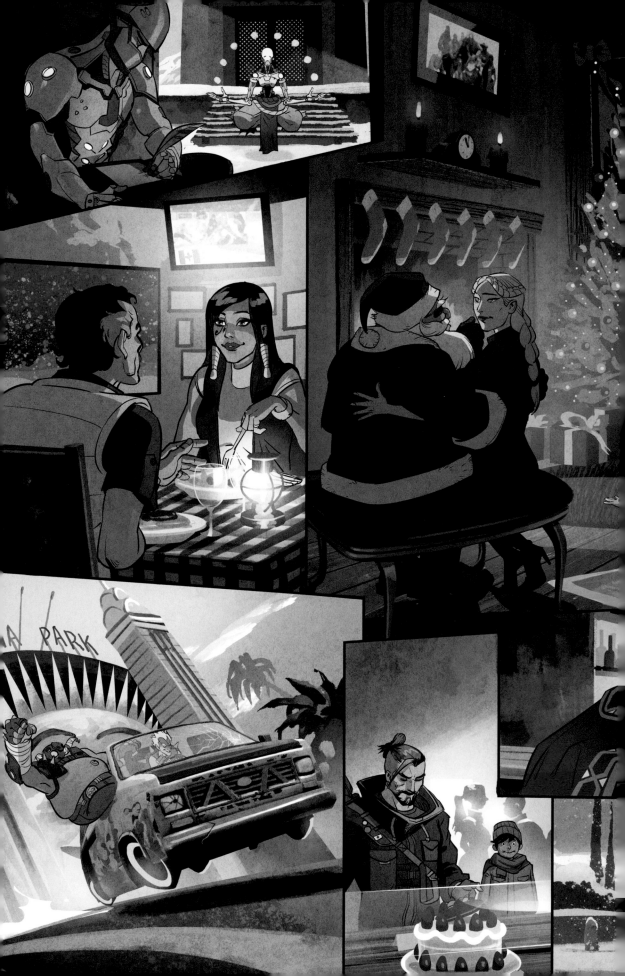

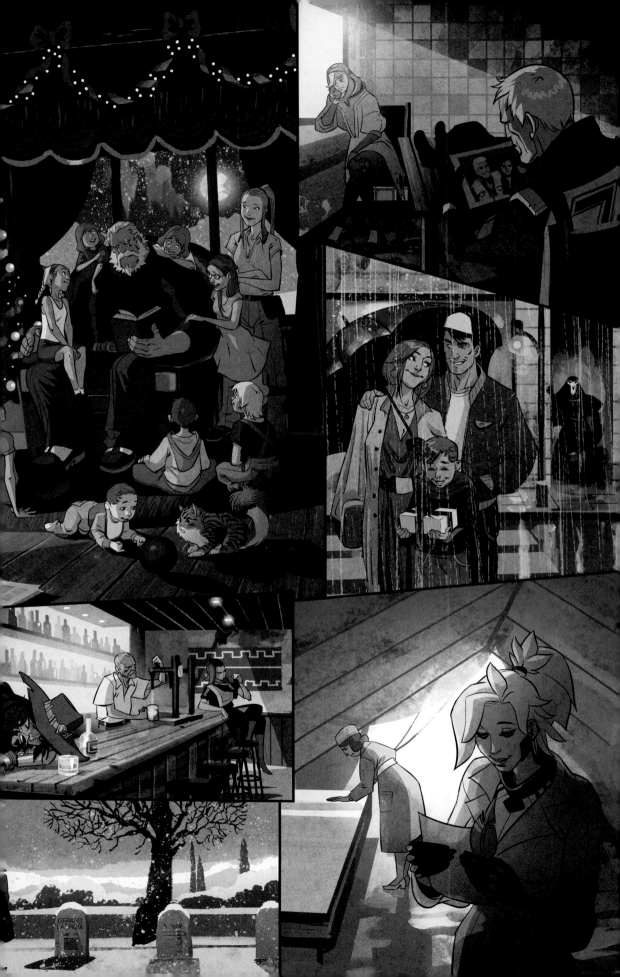

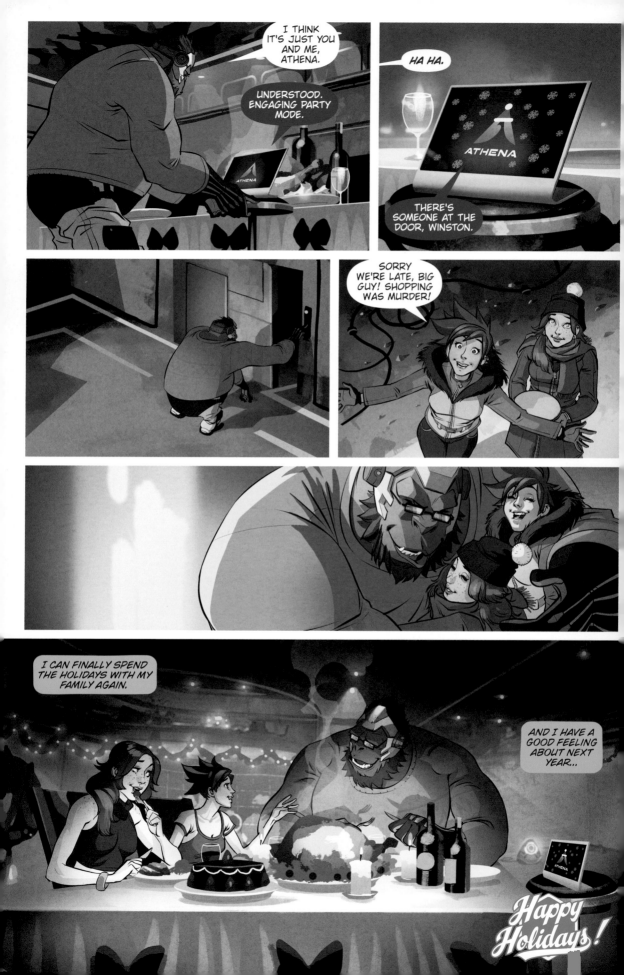

BINARY

SCRIPT BY MATT BURNS, JAMES WAUGH | ART BY JOE NG | COLORS BY ESPEN GRUNDETJERN

LETTERING BY RICHARD STARKINGS AND Comicraft's JOHN ROSHELL,

JIMMY BETANCOURT, AND ALBERT DESCHESNE

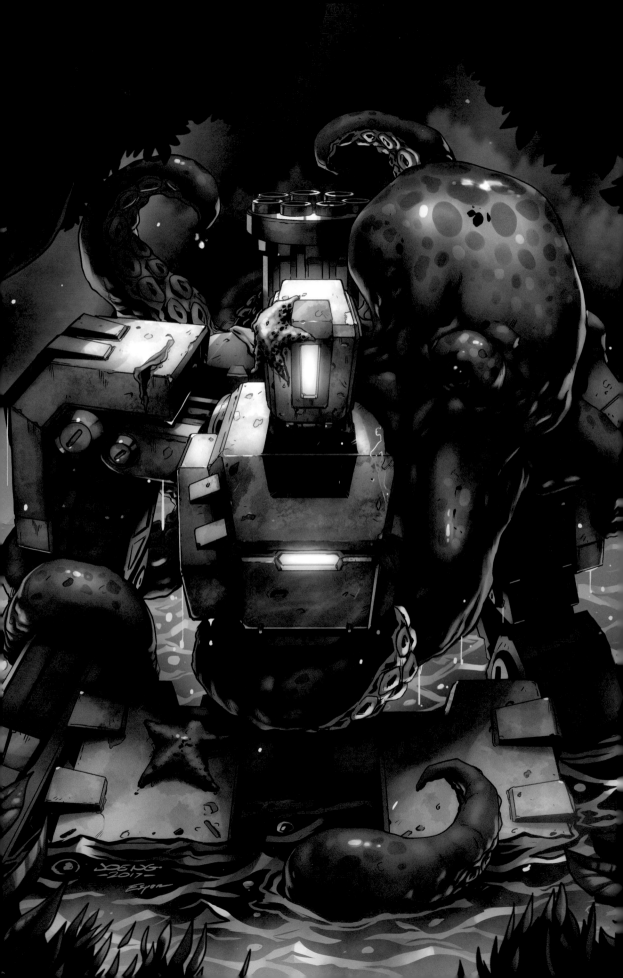

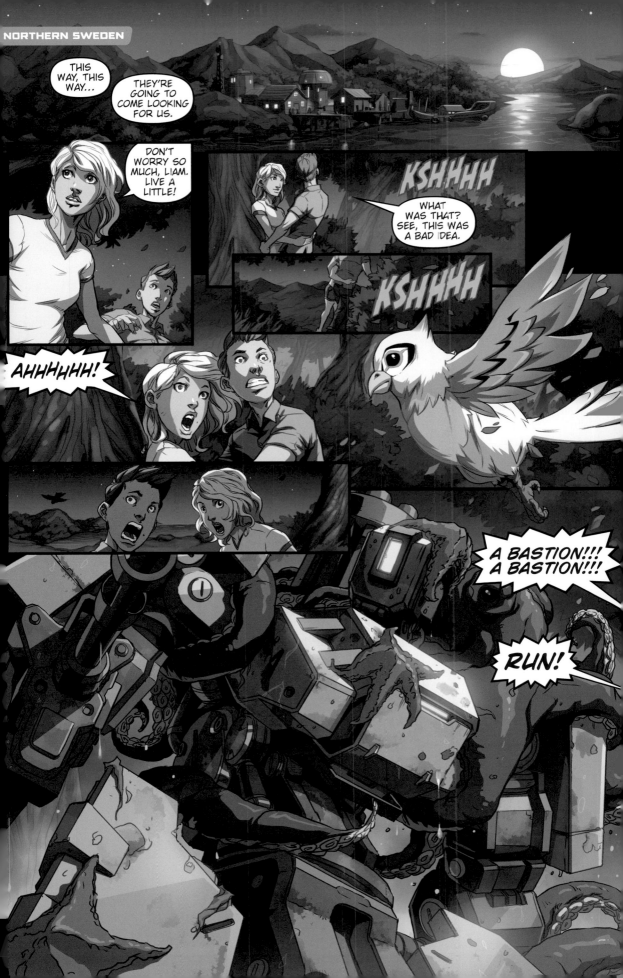

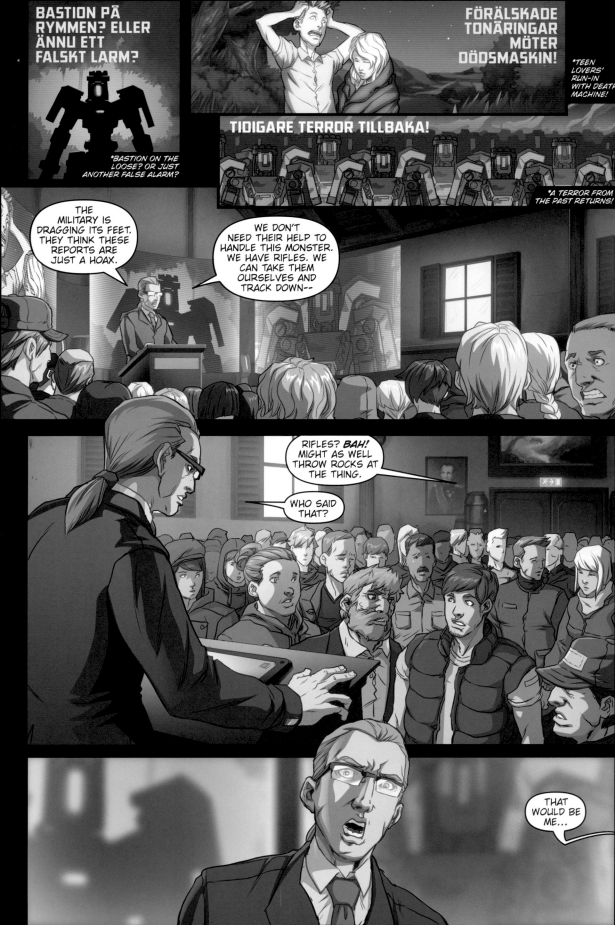

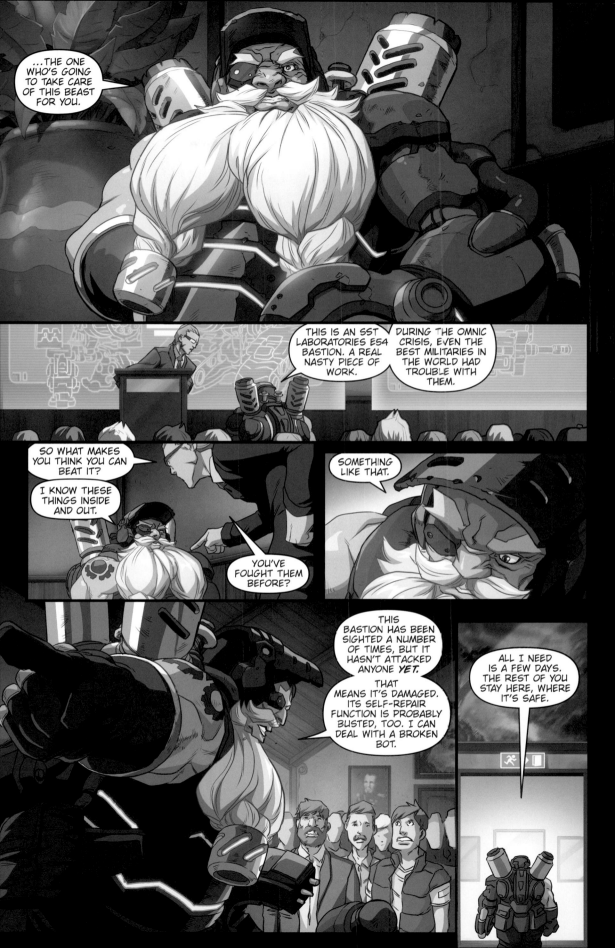

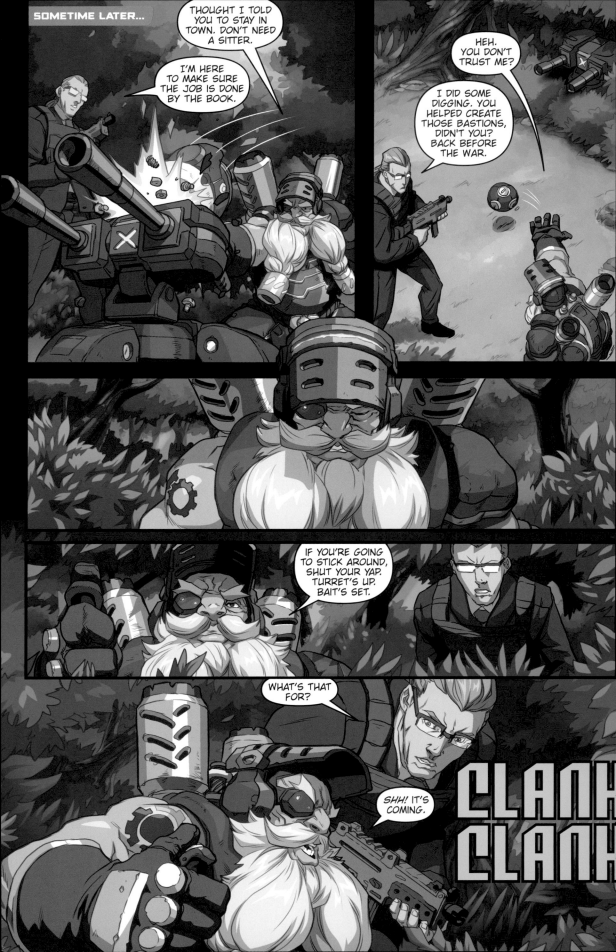

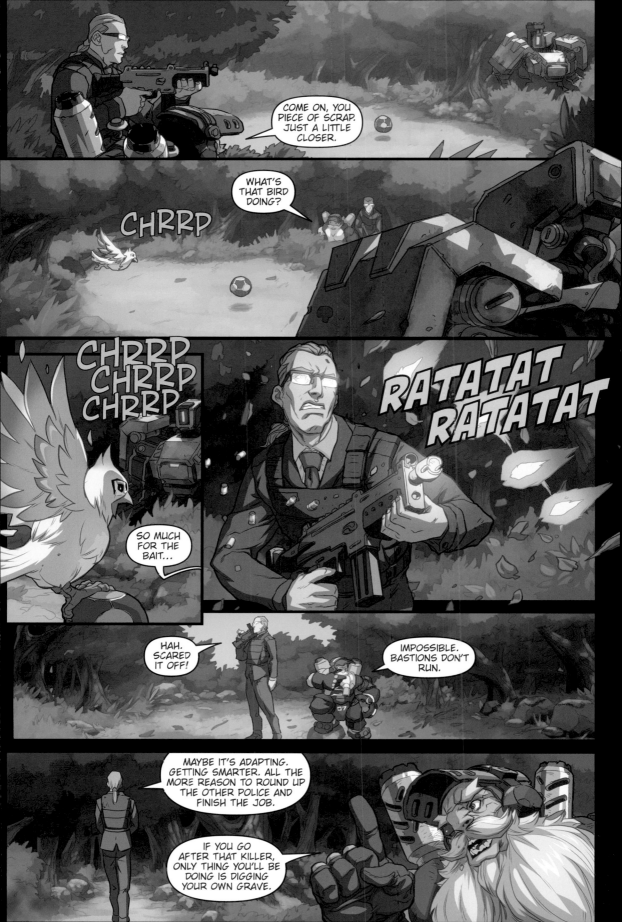

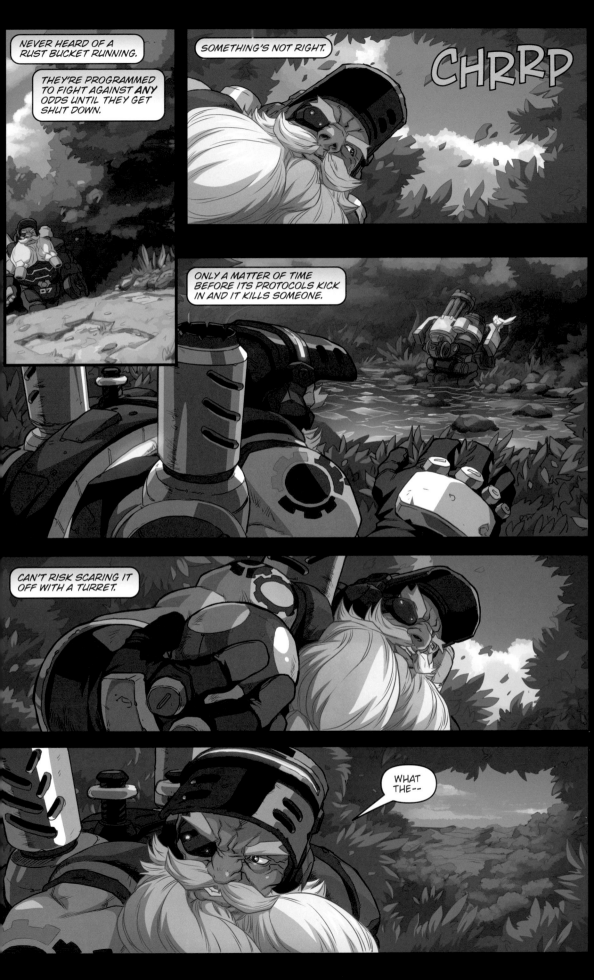

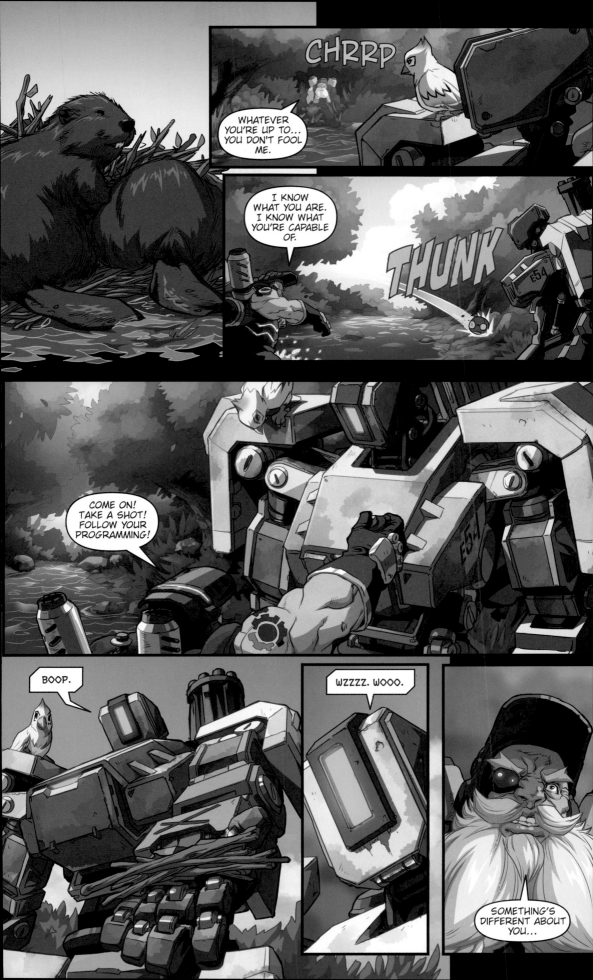

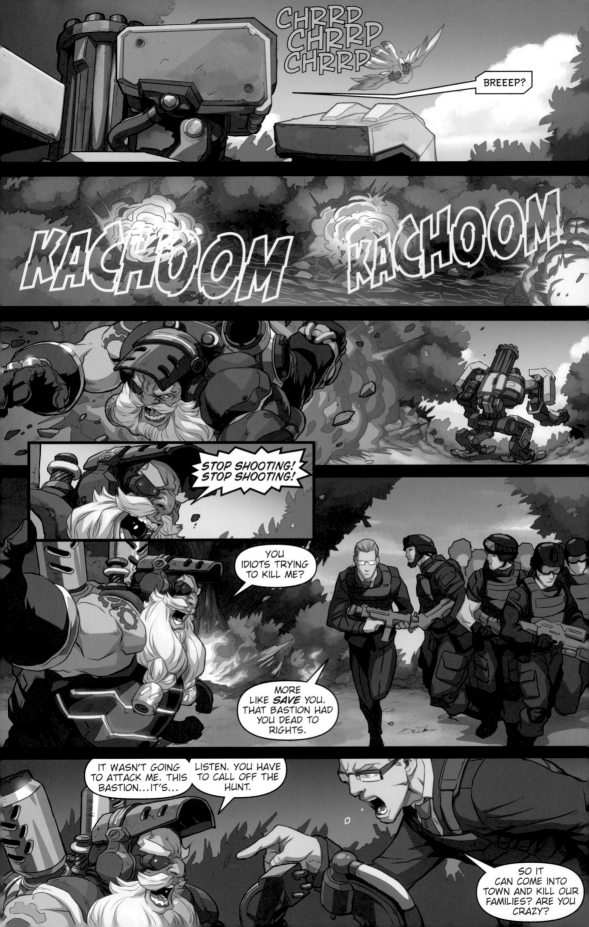

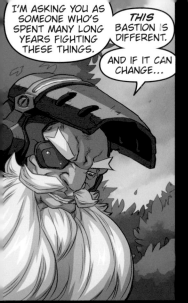

I'M ASKING YOU AS SOMEONE WHO'S SPENT MANY LONG YEARS FIGHTING THESE THINGS.

THIS BASTION IS DIFFERENT.

AND IF IT CAN CHANGE...

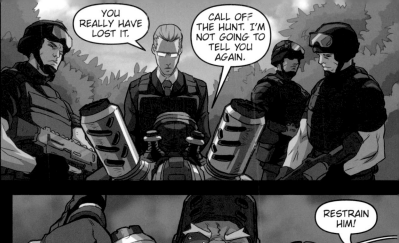

YOU REALLY HAVE LOST IT.

CALL OFF THE HUNT. I'M NOT GOING TO TELL YOU AGAIN.

RESTRAIN HIM!

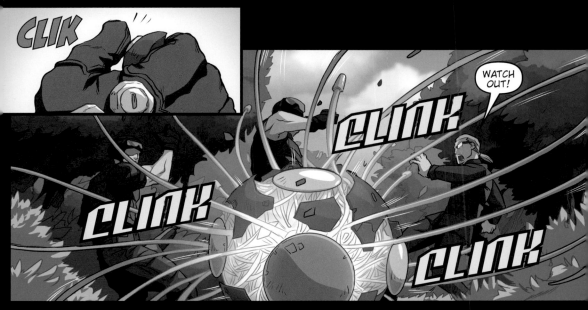

CLIK

WATCH OUT!

CLINK

CLINK

CLINK

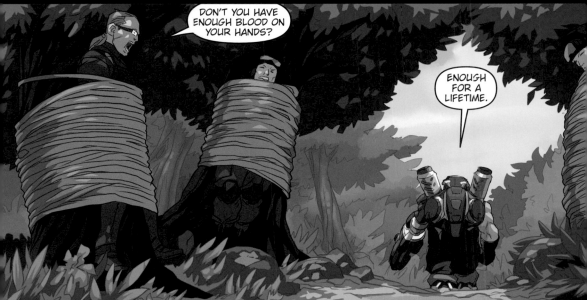

DON'T YOU HAVE ENOUGH BLOOD ON YOUR HANDS?

ENOUGH FOR A LIFETIME.

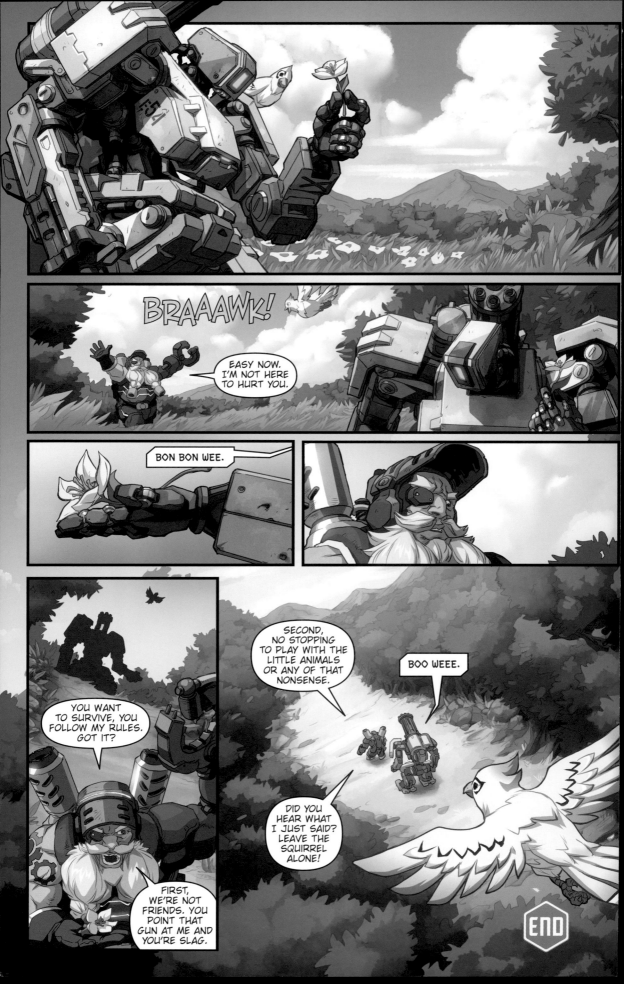

UPRISING

SCRIPT BY MICHAEL CHU | ART BY GRAY SHUKO
LETTERING BY RICHARD STARKINGS AND Comicraft's JOHN ROSHELL,
JIMMY BETANCOURT, AND ALBERT DESCHESNE

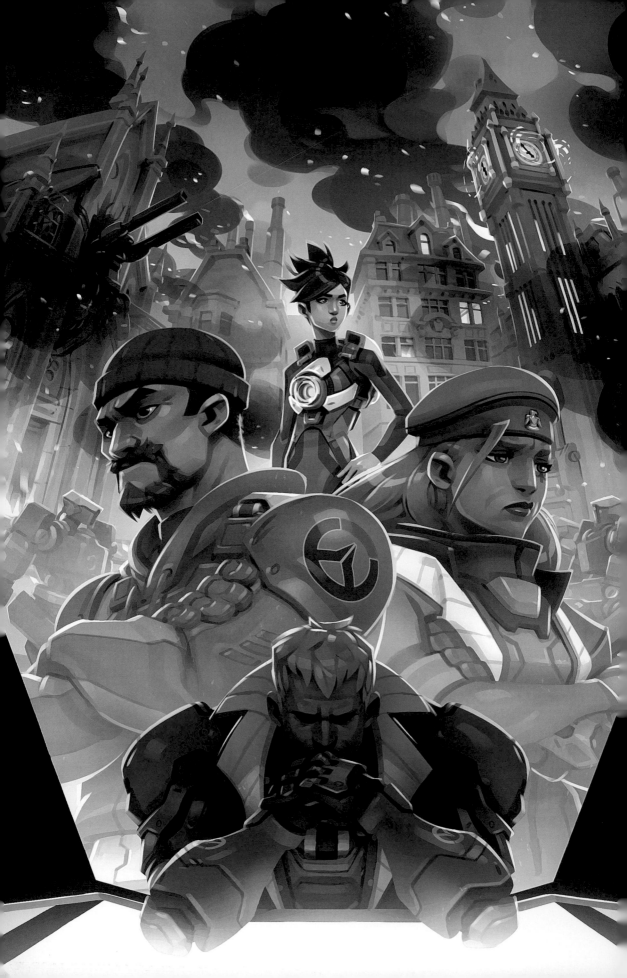

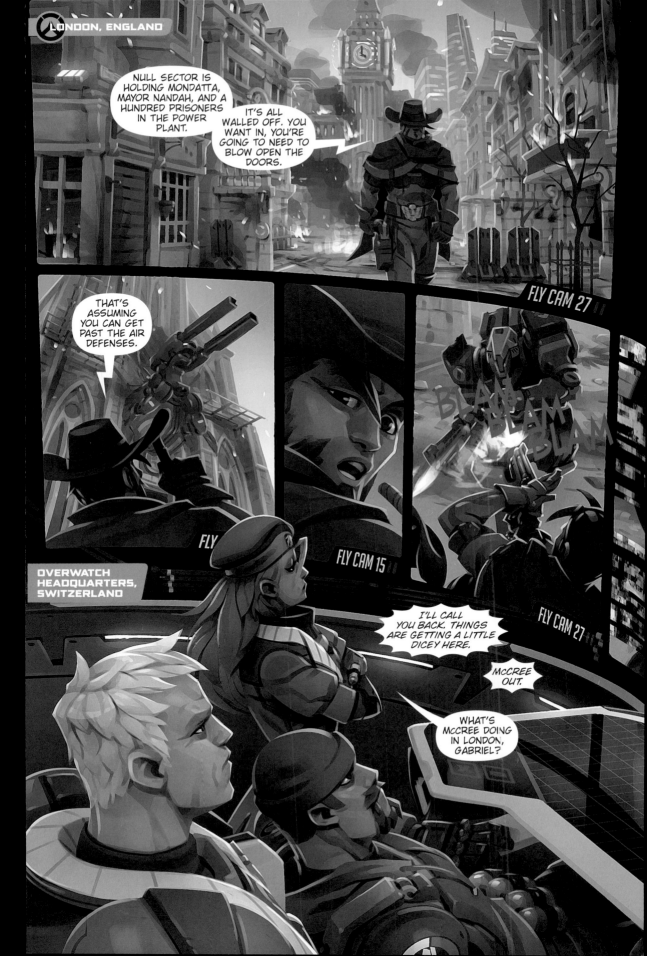

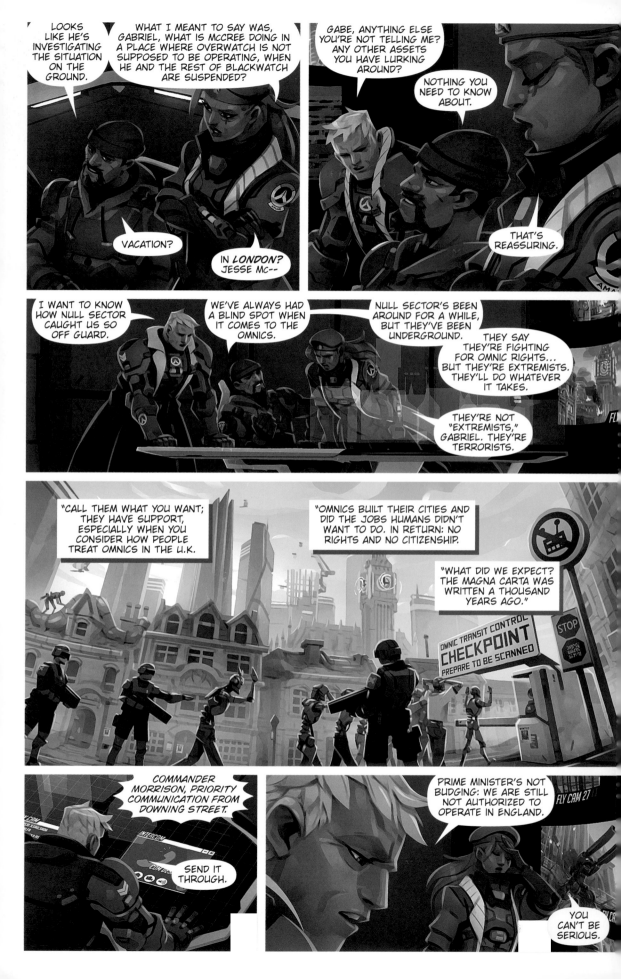

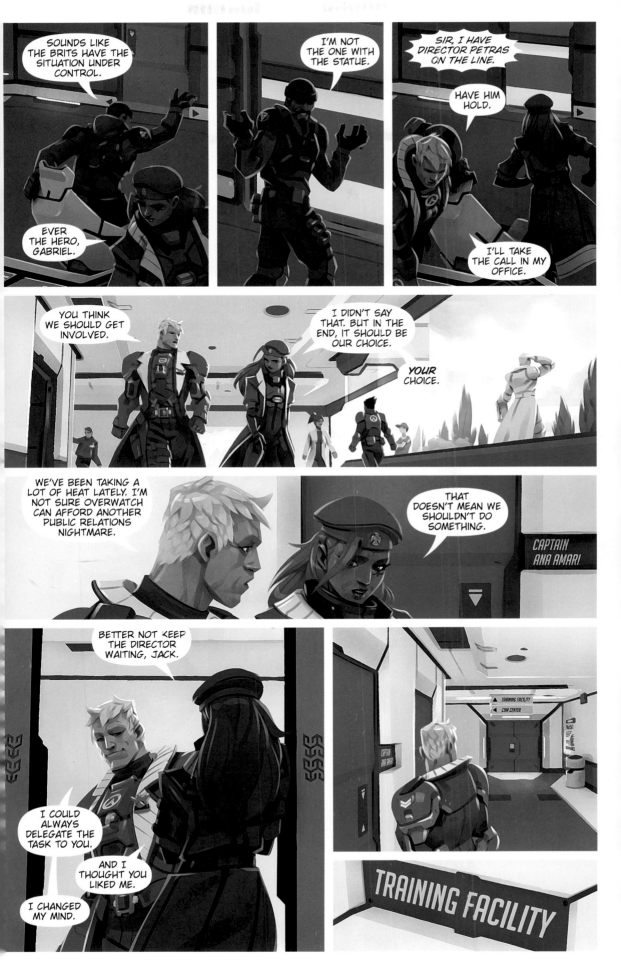

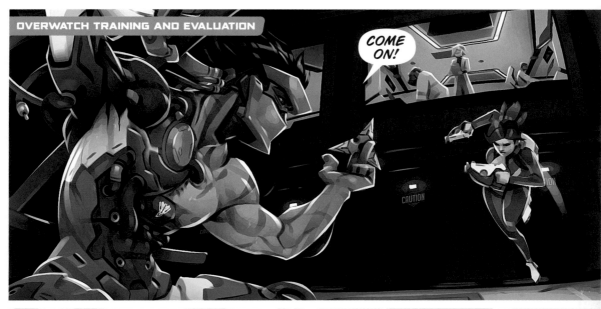

COME ON!

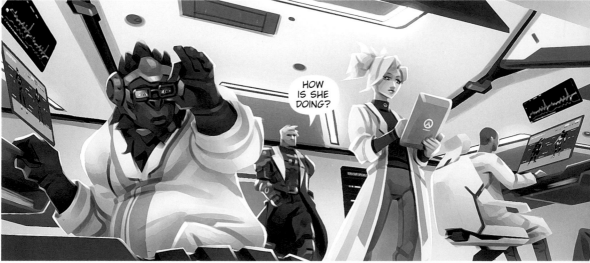

HOW IS SHE DOING?

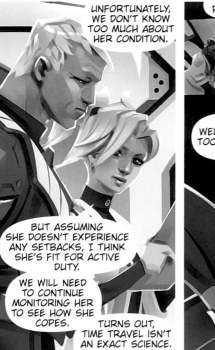

UNFORTUNATELY, WE DON'T KNOW TOO MUCH ABOUT HER CONDITION.

BUT ASSUMING SHE DOESN'T EXPERIENCE ANY SETBACKS, I THINK SHE'S FIT FOR ACTIVE DUTY.

WE WILL NEED TO CONTINUE MONITORING HER TO SEE HOW SHE COPES.

TURNS OUT, TIME TRAVEL ISN'T AN EXACT SCIENCE. IS IT, WINSTON?

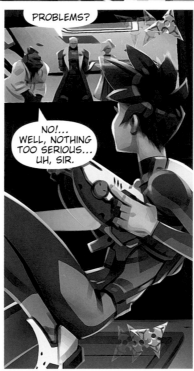

PROBLEMS?

NO!... WELL, NOTHING TOO SERIOUS... UH, SIR.

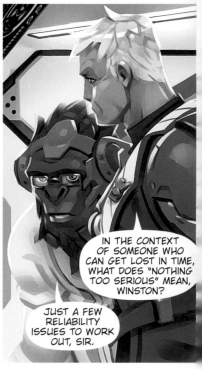

IN THE CONTEXT OF SOMEONE WHO CAN GET LOST IN TIME, WHAT DOES "NOTHING TOO SERIOUS" MEAN, WINSTON?

JUST A FEW RELIABILITY ISSUES TO WORK OUT, SIR.

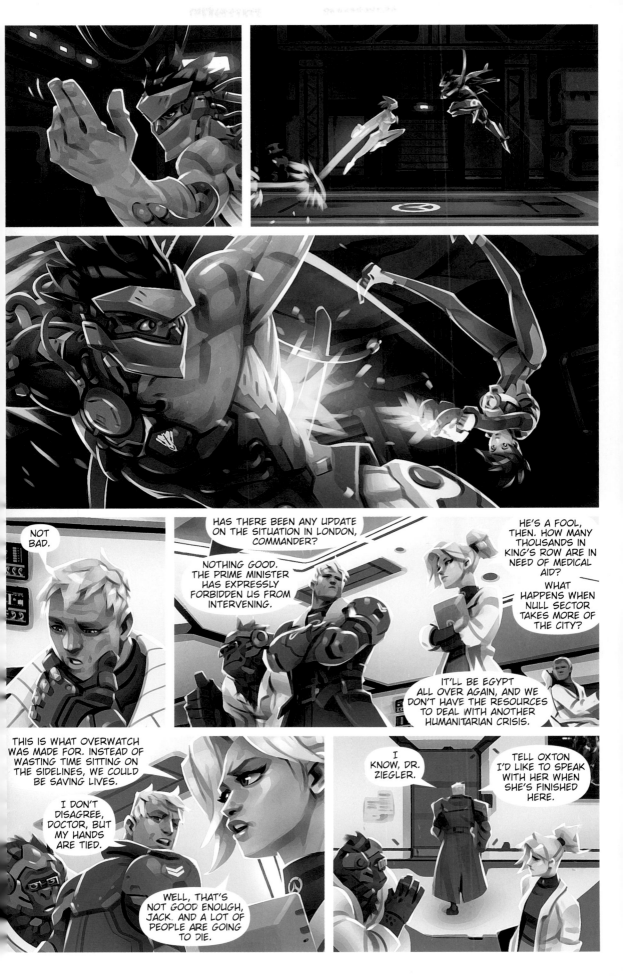

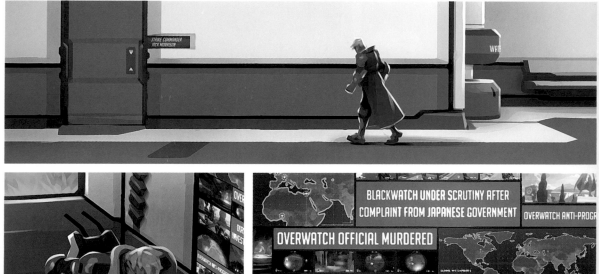

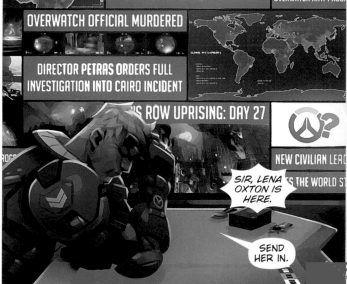

SIR, LENA OXTON IS HERE.

SEND HER IN.

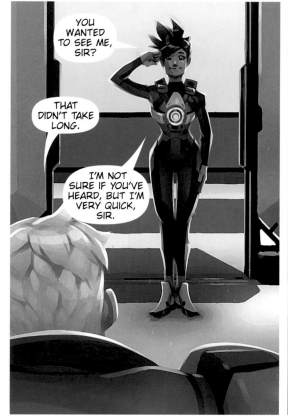

YOU WANTED TO SEE ME, SIR?

THAT DIDN'T TAKE LONG.

I'M NOT SURE IF YOU'VE HEARD, BUT I'M VERY QUICK, SIR.

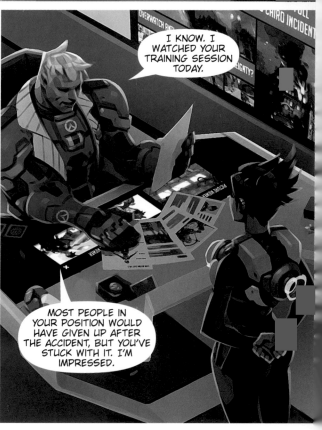

I KNOW. I WATCHED YOUR TRAINING SESSION TODAY.

MOST PEOPLE IN YOUR POSITION WOULD HAVE GIVEN UP AFTER THE ACCIDENT, BUT YOU'VE STUCK WITH IT. I'M IMPRESSED.

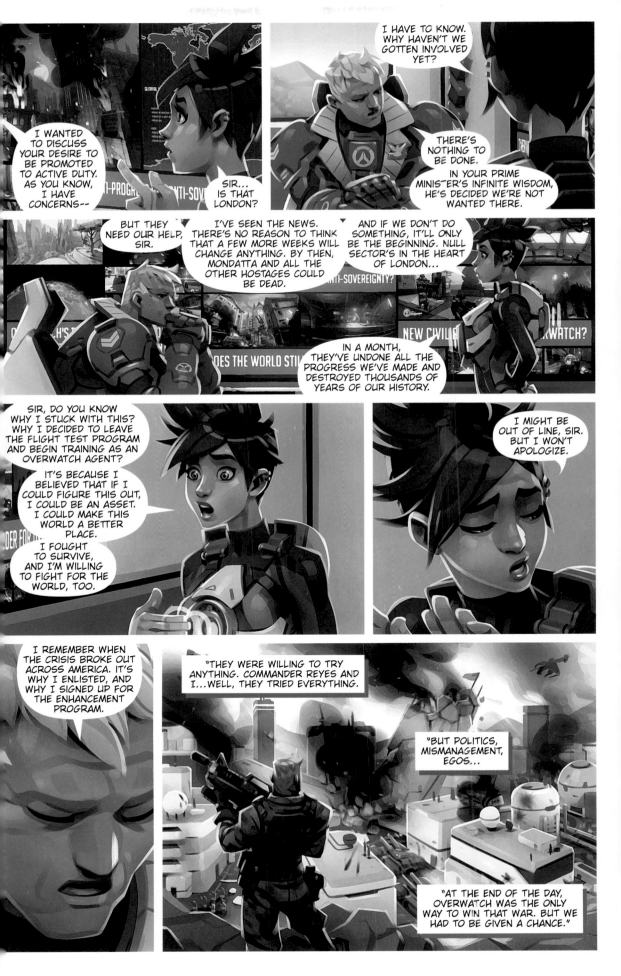

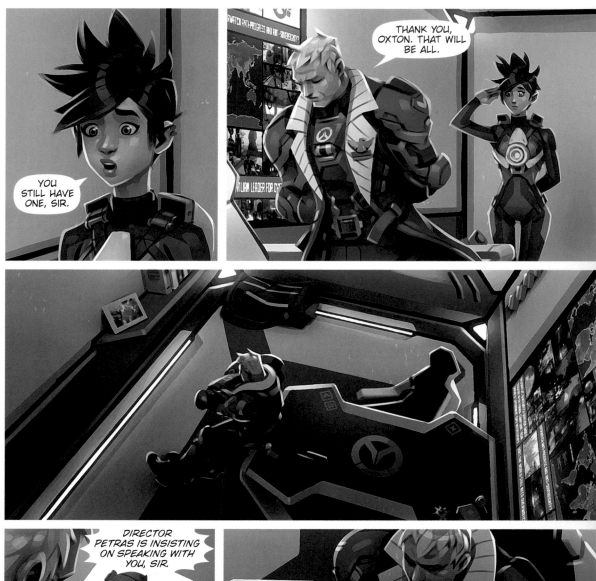

YOU STILL HAVE ONE, SIR.

THANK YOU, OXTON. THAT WILL BE ALL.

DIRECTOR PETRAS IS INSISTING ON SPEAKING WITH YOU, SIR.

VERY WELL. PUT HIM THROUGH.

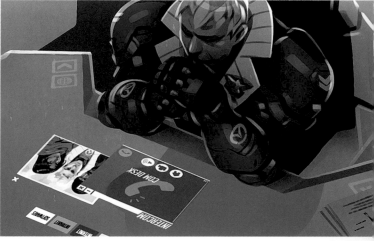

ACTUALLY, TELL HIM I'LL CALL HIM BACK.

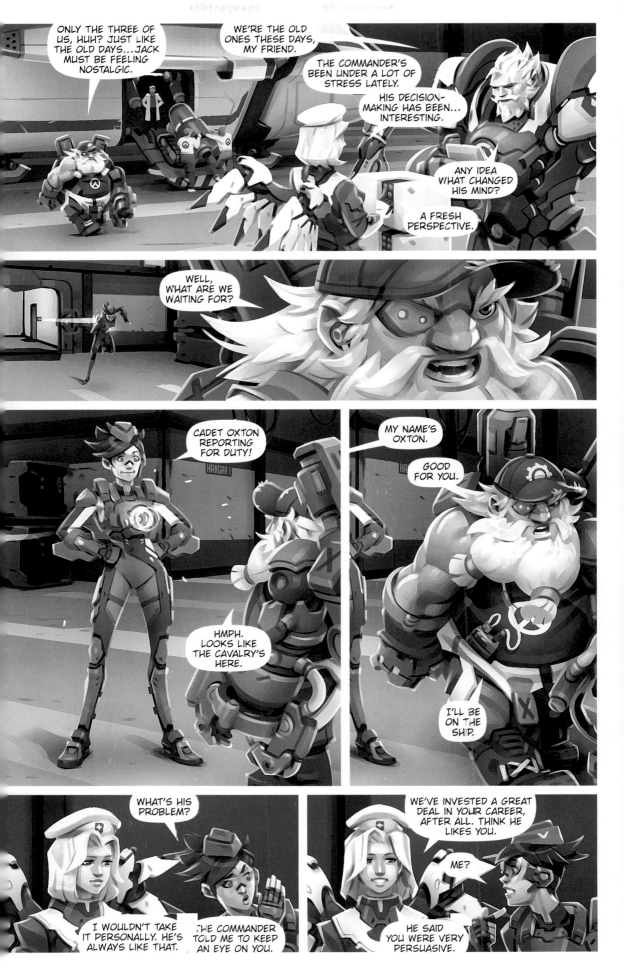

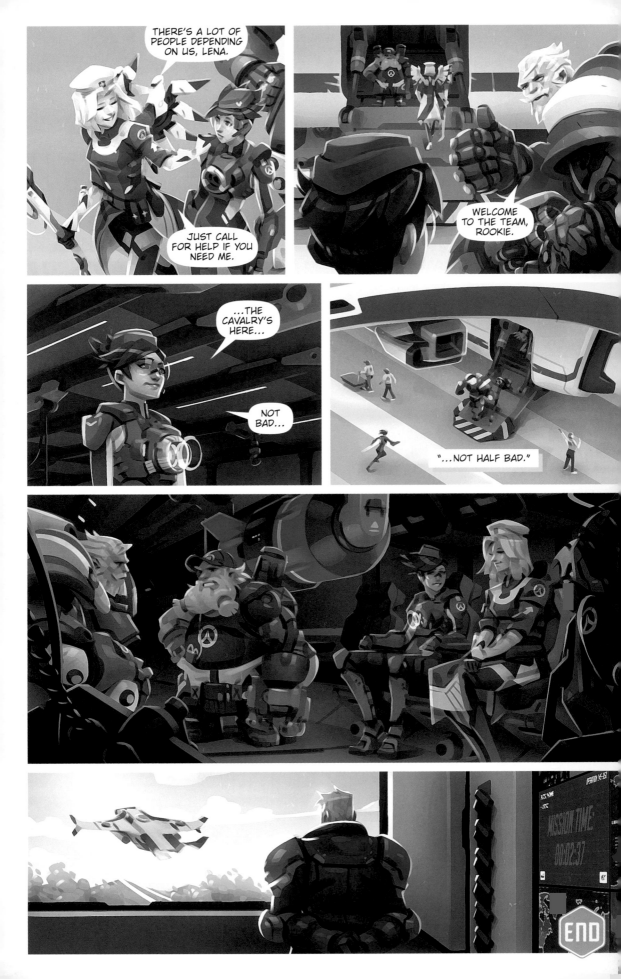

OVERWATCH

ANTHOLOGY
VOLUME 1

SKETCHBOOK

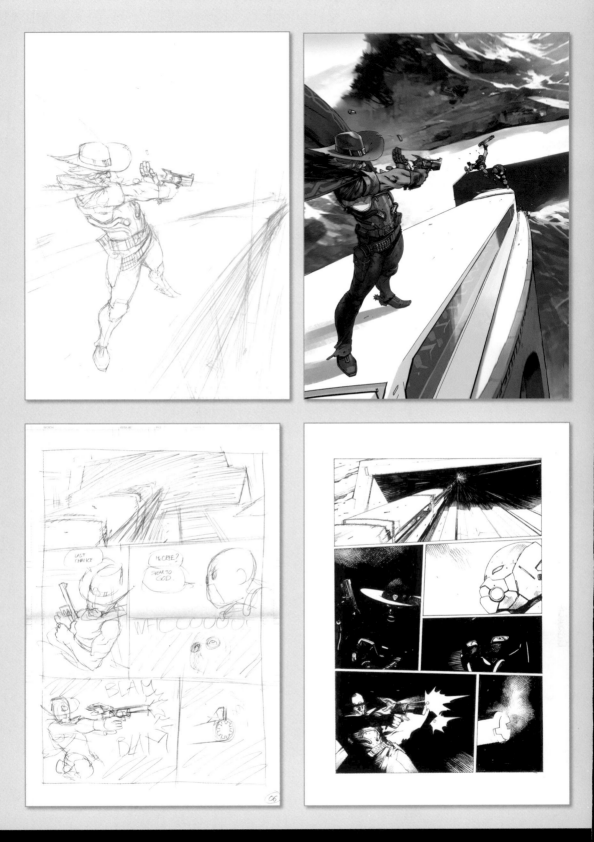

TOP LEFT

Rough concept for the cover of "Train Hopper."

TOP RIGHT

An early color pass on the cover of "Train Hopper." This version featured the train entering a mountain tunnel. The creators later settled on open plains with a blue sky for the environment.

BOTTOM LEFT

Rough layout for page six of "Train Hopper," with placeholder word balloons and sound effects.

BOTTOM RIGHT

The inked version of page six.

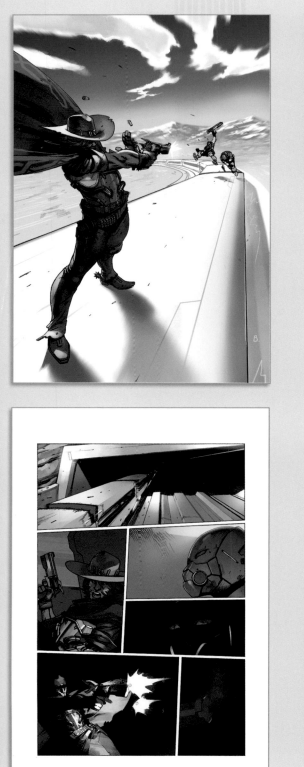
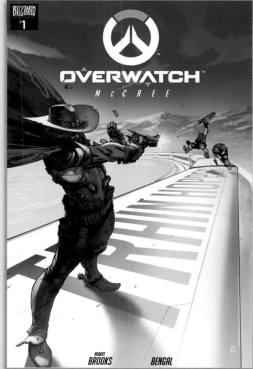
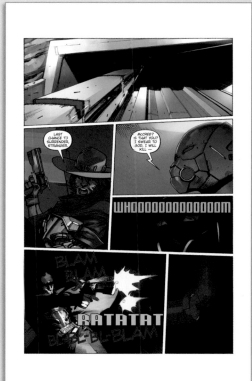

TOP LEFT

Color pass on the "Train Hopper" cover.

TOP RIGHT

Final cover, featuring the credits, title, and other text.

BOTTOM LEFT

Color layout for page six of "Train Hopper."

BOTTOM RIGHT

Final version of page six, with word balloons and sound effects implemented.

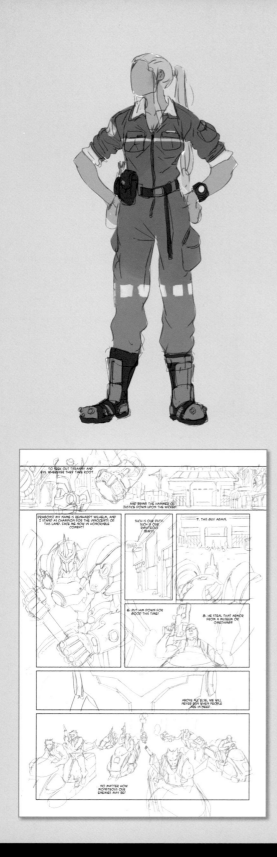

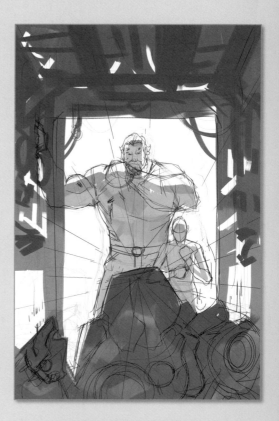

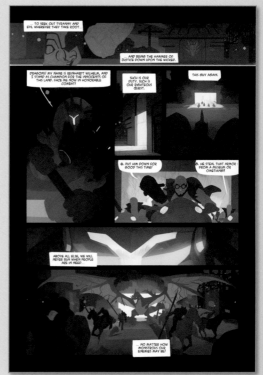

TOP LEFT

Early concept for Brigitte,
Reinhardt's squire in "Dragon
Slayer."

TOP RIGHT

Rough cover concept for
"Dragon Slayer."

BOTTOM LEFT

Rough layout for page five of
"Dragon Slayer."

BOTTOM RIGHT

Color pass of page five. Small
adjustments were made
between this version and the

cover thumbnails

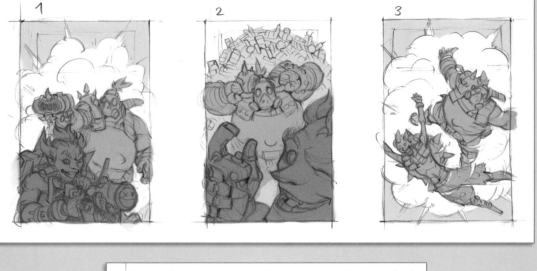

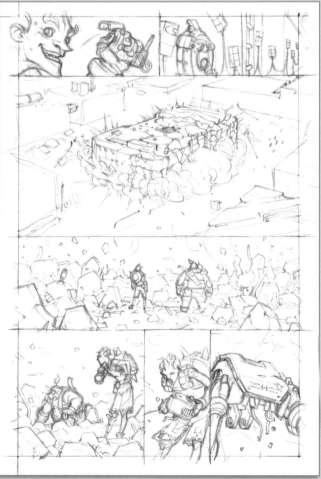

TOP

Rough cover concepts for "Going Legit." The creators chose
to flesh out number three. Slight compositional changes were
made between this concept and the final cover.

BOTTOM

Rough layout for page five of "Going Legit."

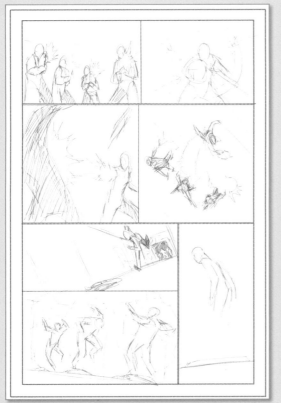

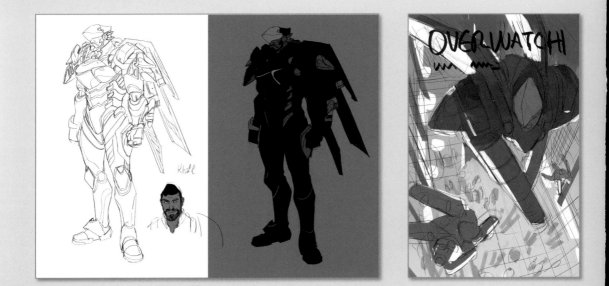

TOP LEFT

Rough layout for page five of "A Better World."

TOP RIGHT

Alternate cover concept of "A Better World" featuring Symmetra in her Vishkar skin.

BOTTOM LEFT

Character concept for Khalil, one of Pharah's comrades in "Mission Statement."

BOTTOM RIGHT

An early cover concept for "Mission Statement." The creators altered the angle of the image in the final version to draw more attention to Pharah and show her face.

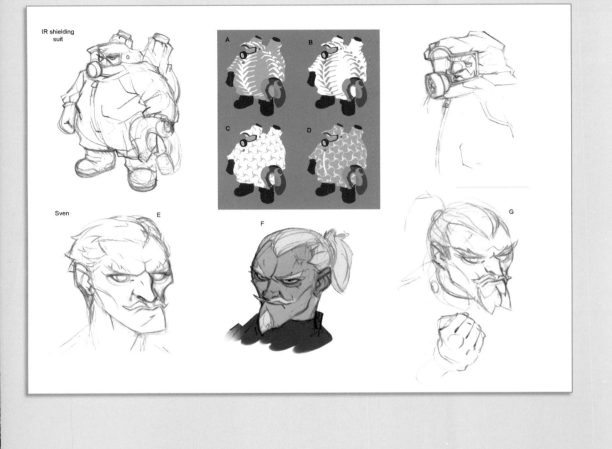

IR shielding suit

A B C D

Sven E

F

G

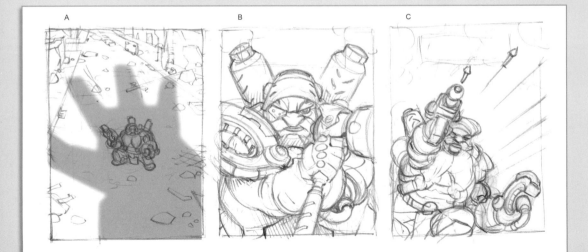

A B C

Concept art for Torbjörn's hazmat suit and Sven, the antagonist of "Destroyer."

Cover concepts for "Destroyer." The creators chose the middle image for the final version.

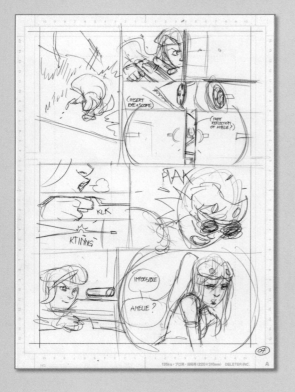

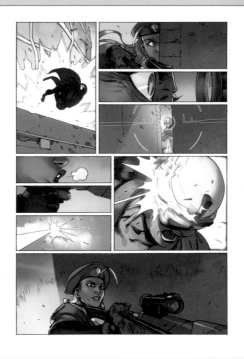

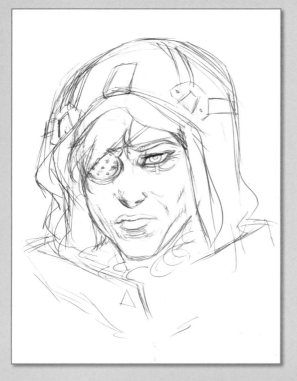

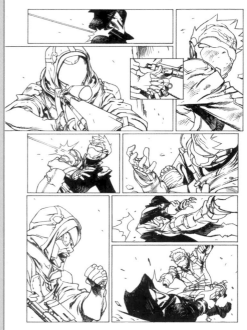

TOP LEFT

Rough layout of page seven for "Legacy."

TOP RIGHT

Color version of page seven. The last panel was adjusted from the rough layout, and revealing the identity of Ana's foe—Amélie Lacroix, otherwise known as Widowmaker—was moved to the next page.

BOTTOM LEFT

Rough cover concept for "Old Soldiers."

BOTTOM RIGHT

Inked version of page four of "Old Soldiers."

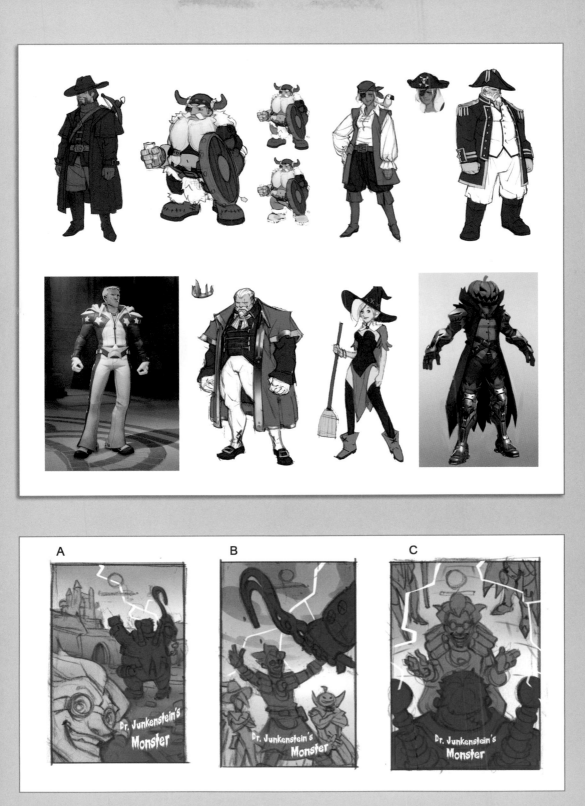

A B C

Costume concepts for the characters who appear in

Cover concepts for "Junkenstein." The rightmost option was

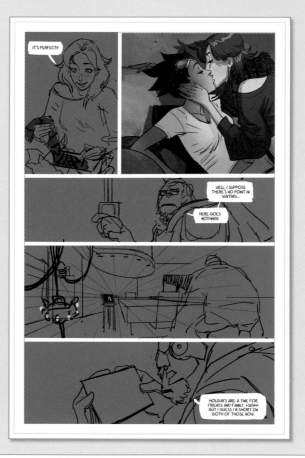

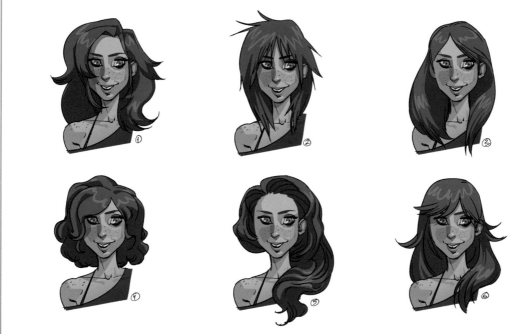

TOP

Rough layout for page seven of "Reflections," with one fully rendered panel.

BOTTOM

Concepts for Emily, Tracer's significant other in "Reflections." The creators chose the top-left image to use for the character's hairstyle.

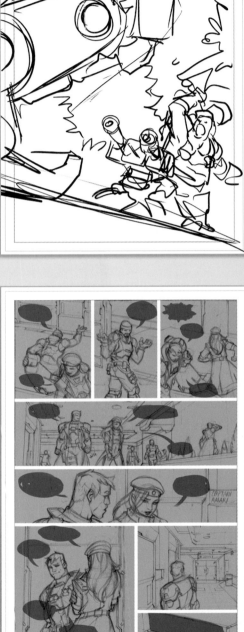

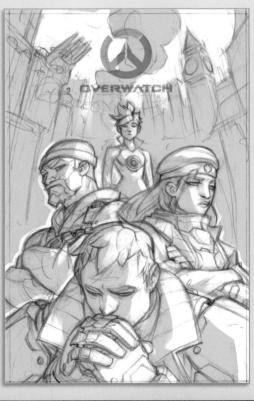

TOP LEFT

Rough cover concept for "Binary."

TOP RIGHT

Rough cover concept for "Binary." The creators ultimately chose a cover without Torbjörn to keep his appearance in the comic a surprise.

BOTTOM LEFT

Rough cover concept for "Uprising."

BOTTOM RIGHT

Rough layout for page three of "Uprising." Word balloons were added in this version to make sure they wouldn't be covering characters' faces or other important details.

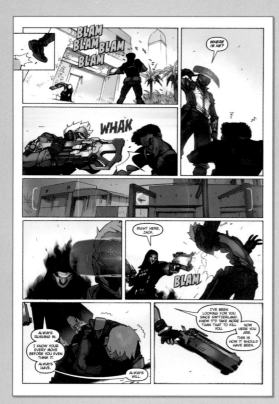

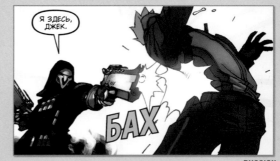

RUSSIAN

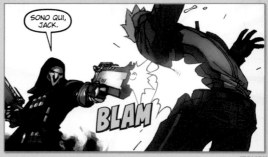

ITALIAN

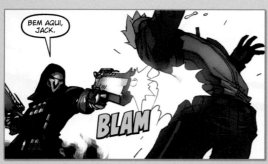

PORTUGUESE

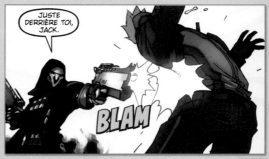

FRENCH

JAPANESE

TRADITIONAL CHINESE

TOP LEFT

Final version of page three of "Old Soldiers." After the English version of the script was approved, it was localized into twelve different languages. This same process applies to every *Overwatch* comic, and it includes translating all forms of text, from dialogue to sound effects.

SURROUNDING IMAGES

After localizing page three of "Old Soldiers," letterers changed the size of word balloons to conform to other languages, such as with Japanese and Traditional Chinese (bottom row).

CREATOR BIOS

BENGAL—Bengal is best known for illustrating several popular European graphic novels, including *Meka*, *Naja*, and *Luminae*; for his recent work for DC Comics on *Batgirl* and *The Adventures of Supergirl*, the tie-in comic to the hit TV series *Supergirl*; and for his current *Spider-Gwen* and *All-New Wolverine* comics for Marvel. His unique style blends the dynamism of Japanese manga and anime with digital painting techniques from the fields of concept art and cover design.

ROBERT BROOKS—Robert Brooks is a senior writer on Blizzard's Creative Development team and has worked on content for all of the company's franchises. He recently co-authored the *New York Times* and *USA Today* bestselling illustrated history book series *World of Warcraft Chronicle*.

MATT BURNS—Matt Burns is a senior writer on Blizzard Entertainment's Creative Development team. During his time at the company, he has helped create licensed and ancillary fiction for the *World of Warcraft*, *StarCraft*, *Diablo*, and *Overwatch* universes. Some of his recent projects include authoring *Diablo III: Book of Tyrael* and co-authoring the *New York Times* and *USA Today* bestselling illustrated history book series *World of Warcraft Chronicle*.

MICHAEL CHU—Michael Chu is the lead writer for *Overwatch* at Blizzard Entertainment, where he began his career in 2000. He has worked on a number of other games, including *World of Warcraft*, *Diablo III*, and *Star Wars: Knights of the Old Republic II*.

JEFFREY "CHAMBA" CRUZ—Jeffrey "Chamba" Cruz is a Melbourne-based comic book artist whose credits include UDON's *Street Fighter II Turbo* series, *Super Street Fighter* volumes 1 and 2, *Skullkickers*, and *Wayward* from Image Comics.

Other properties and companies he's worked for include *Teenage Mutant Ninja Turtles*, Marvel, *Red Sonja*, Warner Bros., Mattel, Universal Pictures, *Mega Man*, DC Comics, IDW, BOOM! Studios, and Dynamite Entertainment.

Above all, his primary goal is to continue work on his original graphic novel *RandomVeus* (also published through UDON) and to continue creating and illustrating.

ESPEN GRUNDETJERN—Espen Grundetjern started his career in 2002 as a colorist on the *Transformers* comic series from Dreamwave Productions. Since 2005 he has colored primarily for UDON Entertainment on its *Street Fighter* and *Darkstalkers* series. Espen has also provided color illustration for video games such as *Tatsunoko vs. Capcom*, *Super Street Fighter II Turbo HD Remix*, and *Super Puzzle Fighter II Turbo HD Remix*, as well as working on concept art, promotional comics, and trading cards.

MIKI MONTLLÓ—Miki Montlló is an artist born in Barcelona and based in Ireland. He has worked in animation (Filmax, Cartoonsaloon, Laika) and comics for twelve years. He is currently working on the last books of his own science fiction saga, *Warship Jolly Roger*, published by Dargaud and Magnetic Press.

MICKY NEILSON—Micky Neilson worked at Blizzard Entertainment for twenty-two years, where his game-writing credits included *World of Warcraft*, *StarCraft*, *Warcraft III*, and *Lost Vikings 2*. Micky's first comic book, *World of Warcraft: Ashbringer*, hit #2 on the *New York Times* Best Sellers list for Hardcover Graphic Books. His graphic novel, *World of Warcraft: Pearl of Pandaria*, reached #3 on the *New York Times* Best Sellers list. In 2014, his *Diablo III* novella, *Morbed*, was published, as well as his long-awaited novella *Blood of the Highborne*. With the understanding support of his wife, Tiffany, and daughter, Tatiana, Micky looks forward to finding dark, quiet corners of the house to write in for years to come.

NESSKAIN—Born in 1987, Nesskain is a French comic artist residing near Paris. He started drawing around the end of high school, but he began to take it seriously around age twenty and spent all of his time practicing. He always desired to go to art school, so after getting a degree in engineering at twenty-two, he commenced his studies in comics, illustration, and animation—but left after six months. Mainly self-taught, he started working in the comics field the following year for the publisher Delcourt. His graphic novels include *Le Cercle* and *R.U.S.T.*

JOE NG—Joe Ng is an illustrator from Toronto, Canada, and has worked on comics for *Transformers*, *G.I. Joe*, and *Street Fighter*. He has recently finished working on the twelve-issue *Street Fighter Unlimited* series for UDON Entertainment

ANDREW ROBINSON—Andrew Robinson has written and consulted for some thirty animated TV shows in the last sixteen years, including co-creating and overseeing the series *Kaijudo: Rise of the Duel Masters*, which ran two seasons. Lured by the incredible storytelling potential he saw in Blizzard's games, he joined the company at the end of 2014, and has been happily writing cinematic shorts and in-game content—and now comics—for its various intellectual properties since then.

GRAY SHUKO—A comics and concept artist, Gray Shuko has worked mainly for video game companies, in French studios, and at Blizzard. He is now a freelance artist focusing on PC and mobile games and on his new comic, *Fruity Frags*, which can be read on gray-shuko.net. Gray also spends time testing and upgrading his coloring technique, often by making fan art for two of his favorite franchises: *Dragon Ball Z* and *Metal Gear Solid*.

JAMES WAUGH—James Waugh is the former Senior Director of Story & Creative Development at Blizzard Entertainment, where he was instrumental in the development of the *Overwatch* universe, guiding the original slate of animated shorts, comics, and other media that helped introduce Blizzard's first new intellectual property in seventeen years. After eight years of developing the worlds of Azeroth, Sanctuary, and the Koprulu sector, he left Blizzard Entertainment in October 2016.

Currently Waugh serves as a Vice President of Development at Lucasfilm. Blizzard and its amazing universes (and amazing people) will always be near and dear to his heart.